stylish mosaics

over 20 contemporary projects for your home

Anne Cardwell

hamlyn

the author
Anne Cardwell trained as a graphic designer and worked in leading London design consultancies, before turning to mosaics. Blending her artistic talent and flair for interior design with her love of working with and inspiring others, Anne runs mosaic community projects, offers mosaic workshops for all ages and accepts commissions to make beautiful, contemporary mosaics.

An Hachette UK Company
www.hachette.co.uk

First published in Great Britain in 2010 by Hamlyn,
a division of Octopus Publishing Group Ltd
2–4 Heron Quays, London E14 4JP
www.octopusbooks.co.uk

ISBN: 978-0-600-61879-9

A CIP catalogue record for this book is available from the British Library.

Printed and bound in China

10 9 8 7 6 5 4 3 2 1

Disclaimer
The publisher cannot accept any legal responsibility or liability for accidents or damage arising from the use of any items mentioned in this book or in the carrying out of any of the projects.

contents

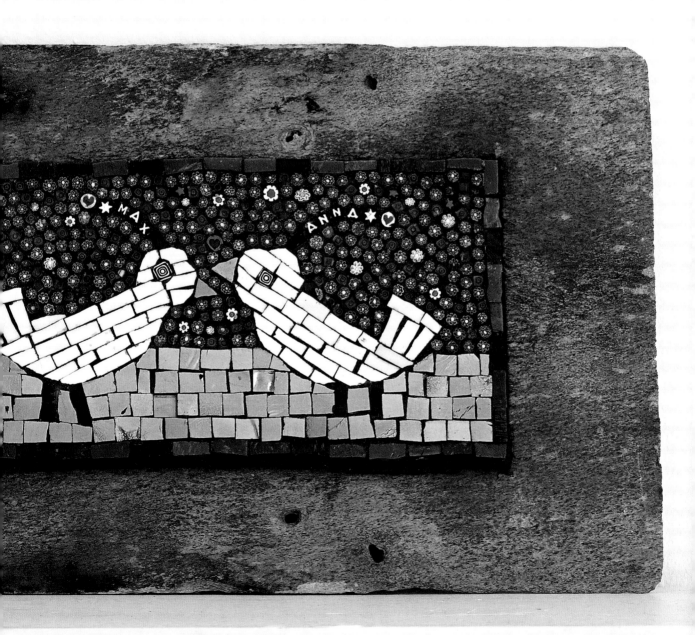

introduction

It may seem daunting at first, but mosaic making is actually surprisingly easy and you really don't need to be 'good at art'. After mastering just a few basic principles, even your first tentative efforts are guaranteed to produce an attractive and unique creation that will delight you and brighten your home. In fact the wonderful mosaic materials now available do much of the work for you!

The first mosaics were made by the Greeks in pebble and stone, and the sophisticated designs that have survived from Roman times still amaze us over two thousand years later. The early Christian and subsequent Byzantine era (about AD 500) saw more sophisticated smalti work being produced, of which the mosaics in Ravenna in Italy are the most well known. Initially used only in moderation, glass was now being produced and used in a wide range of glittering colours and highlighted generously with vast amounts of gold. Mosaic was predominately commissioned for church decoration.

Mosaic was superseded by painting after the Renaissance, but the decline was reversed at the beginning of the 20th century with the arrival of Art Nouveau and a renewed interest in detail and surface pattern. The revival of mosaics was further encouraged by modernists such as Gaudí and collaborators who between them mosaiced over much of Barcelona! Later in the century, and influenced by Gaudí's Park Guell, French artist Niki de Saint Phalle created The Tarot Garden in Italy. The history of mosaic is not confined to Europe. Many other cultures have embraced it over the centuries – from the mosaic-encrusted ornate masks made by the Aztecs in South America to the stylish and complicated patterns of Islamic art.

Making mosaics

A mosaic is simply a picture made up from many pieces, referred to as tesserae (from the Latin word for cube, *tessera*) or tiles in this book. Cutting and laying these tesserae in some kind of logical way is the key to making a coherent image rather than just a chaotic muddle. To achieve this as a beginner it's best to keep things simple – start off working with clear silhouettes and strongly contrasting colours. And since it is easier to work on a larger scale, avoid cramping your work on a tiny board. Simple tips such as these will start you off on what will become a very rewarding journey. Seek inspiration in the world around you. Be it the magnificent interior of a cathedral, an animal from the natural world or an obscure pattern on the edge of a plate, something will capture your imagination. As your own style emerges and your skills develop, you will learn to experiment with colours and materials to create designs that reflect your own interests and personality.

The projects in this book are graded in skill level from 1 to 4 but each and every one of the projects is designed to encourage the beginner, as well as inspire the more advanced mosaic maker to attempt innovative designs and work with beautiful materials in order to make the home environment more dramatic. I'm confident that you will enjoy the process of making them, just as much as you will appreciate everyday objects becoming a colourful focal point in your home. Don't be afraid to adapt the projects featured in this book to suit your own creativity and experiment with your own ideas.
Have fun!

Anne Cardwell

mosaic materials

There is a veritable Aladdin's cave of wonderful materials available to the mosaicist today. Each material has its own quality – shiny, matt, reflective or transparent – and all influence the look of the finished work. Choose your material carefully according to whether the mosaic will be positioned indoors or outside, trodden underfoot or simply displayed decoratively.

Smalti

Italian smalti is an intensely coloured enamelled glass available in a wonderful range of colours. A traditional material used by Byzantine and Venetian artists, it is still manufactured in Italy. It is handmade by pouring the molten glass into large circles like pizzas, which are left to cool and later cut into brilliantly reflective rectangular bricks, measuring about 20 mm (3/4 in) long and 10 mm (3/8 in) thick. It is the inside of the 'pizza' that forms the uneven front and back of the briquettes. The top and bottom of the 'pizza' form the sides, which are totally flat and are not so often used. The unevenness of the finished surface means that mosaics made using smalti are often left ungrouted because grout gets caught in the pitted, uneven surface and dulls the colours. There is also a range of translucent glass, cut into brick-shaped tesserae like smalti, but these are not technically 'the real thing'.

Mexican smalti is made in a similar way. It is poured into discs called 'tortillas' and the pieces are cut into irregular squares, the top and bottom of the tortilla being the face displayed in the mosaic. One face is often shiny, the other matt with variegated colouring and mottling. Mexican smalti is more uniform in thickness and therefore suitable for a smooth finish for table tops and even floors in areas of low traffic.

Both types of smalti are expensive. A less expensive option is to purchase 'roti', the imperfect edges of the discs, which are often sold in mixed bags. Smalti is not particularly easy to use, but it is beautiful and used even in small quantities adds a luxurious feel to any mosaic.

Vitreous glass

Vitreous glass is one of the most readily available materials for mosaic work. The tiles are a uniform size – 20 mm (3/4 in) square and 4 mm (5/32 in) deep, usually opaque and with a flat front and a ridged reverse to help the glue adhere. Bisazza is one of the leading manufacturers of luxury glass mosaic tiles and offers a

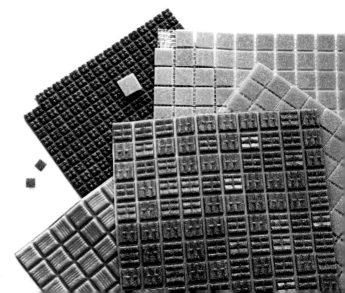

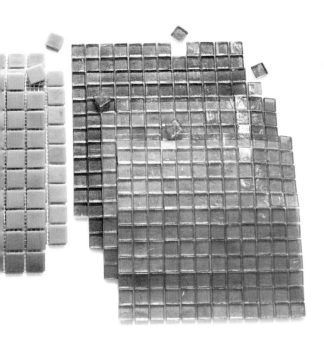

Sicis glass

Sicis glass collections are a modern range of opaque, translucent and iridescent tiles measuring 15 mm (5/8 in) square and 4 mm (5/32 in) thick. Sicis Murano Smalto is essentially smalti glass, with its wonderful intensity, pressed into sheets and comes in a huge range of lovely colours, some of which fill the gaps left wanting by the vitreous glass range. The Sicis Waterglass, Iridium and Glimmer mosaic ranges have an irregular colour variation, which can be seen within a single sheet. Waterglass is transparent and is excellent for 'glass on glass' projects. Iridium, which is opaque, has a wonderful reflective oily surface and provides a range of more subtle colours. Glimmer is the marriage of Waterglass and Iridium, with a translucent shimmery surface. Although expensive, Sicis tiles are irresistible – they work well with other materials, are fantastically easy to cut and work either way up as they have no ridged face.

large range of bright and muted colours, available from specialist suppliers. A Bisazza range called Gemme has copper blended into the glass, creating an enticing gold vein running through the tiles.

Vitreous glass is easy to cut and is suitable for intricate work. It generally comes in paper-faced sheets of 225 tiles – soak the tiles off the paper by placing them in warm water. The cost of vitreous glass tiles depends on the colour – bright colours, pink, black and gold vein are more expensive then whites, blues, greens and beiges. Some mosaic craft suppliers will conveniently divide sheets up.

In recent years vitreous glass tiles have been produced in China. Although considerably cheaper, these tiles are of an inferior quality, making them harder to shape for mosaic work. Nevertheless, they come in interesting colours not included in other ranges and so expand the colour palette of the mosaicist. Be aware that because they are heavily ridged on the reverse, they tend to shatter more easily when being cut. Also, some come backed with mesh from which they are very hard to detach. Luckily some mosaic craft suppliers will sell tiles loose for a small premium and different colours in the range are fairly similar in price.

For either of the above types of vitreous glass, a good way to acquaint yourself with the materials and colours available is to buy a large mixed box, which will contain a good selection of all the colours available.

All vitreous glass is frost proof and waterproof, but not suitable for floors, as it can be broken in situ.

Gold, metallic and mirror tiles

Made in Italy, gold leaf smalti is the most opulent and expensive of mosaic materials, extremely reflective on one face with a deep green or blue glass on the other. Metal leaf is sandwiched between two layers of glass, one thick to provide a strong base and one thin to protect the gold colour. There are about 20 metallic colours (ranging from silver to red and bronze) and there is also a rippled version. Gold leaf smalti can be bought as 'spitzi' offcuts. Although irregular in size and sometimes scratched, these are perfect for the mosaic maker.

Less expensive metallic tiles are available but may not withstand being used outdoors. Mirror is available in many different colours and textures and can be used effectively to achieve a similar effect. It is also possible to adhere foil to the back of tiles or on to a base to achieve a reflective look. When using glittery tiles, remember the saying 'less is more', as they can be very overpowering.

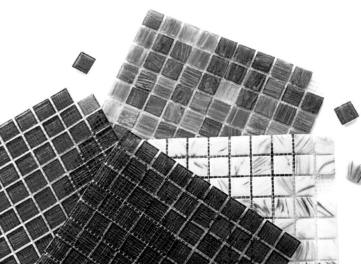

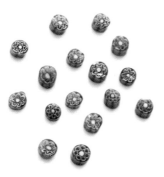

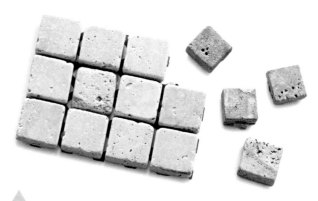

Millefiori

These are tiny handmade rods of glass with colourful flowery patterns and geometric designs – even letters, which are great for personalizing items (see Lovebirds Wedding Plaque, page 114). They are created as rods but usually supplied cut into usable sized beads. Many suppliers conveniently sort them into patterns or mixes of the same colour. Although expensive, millefiori are indispensable for adding detail to mosaic work.

Stained glass

Stained glass can be used in mosaic projects although it is slightly thinner than most other tiles used in mosaic work. Its translucent properties are the most obvious characteristics to exploit, but many also have fabulous textures. Whole sheets are complete works of art in themselves and integrate into mosaic work with stunning results. A trip to a stained glass warehouse is a visit into another world of wonderful possibilities.

Marble

An irresistibly smooth, expensive material, traditionally used in Roman mosaics, marble is available in a range of natural colours: cream, white, brown, green, black and tan. It is thicker and heavier than other materials making it harder to use and therefore best suited to large designs (see Marble Fish Table Top, page 54). Available in sheets of individual tiles, or in lengths called rods, marble can be shaped with tile nippers, especially long-handled side biters (see page 12). Another option is to use a hammer and hardy, specialized cutting equipment not often used by the amateur mosaicist. When choosing colours to use, bear in mind that lighter colours of marble tend to be more manageable and easier to cut.

Stone masons often have usable offcuts to give away or sell. Alternatively, internet auction sites are often a good source of ends of lines and bargains.

Pebbles

There is no way to cut pebbles, but collect lots of different colours, shapes and sizes, and you can make patterns and pictures by setting them into a wet bed of concrete (see Pebble Stepping Stones, page 76).

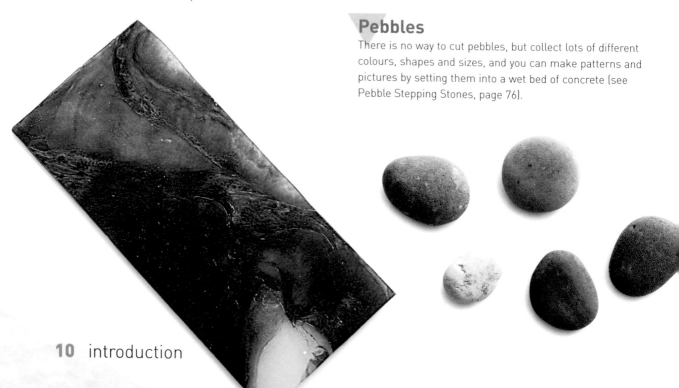

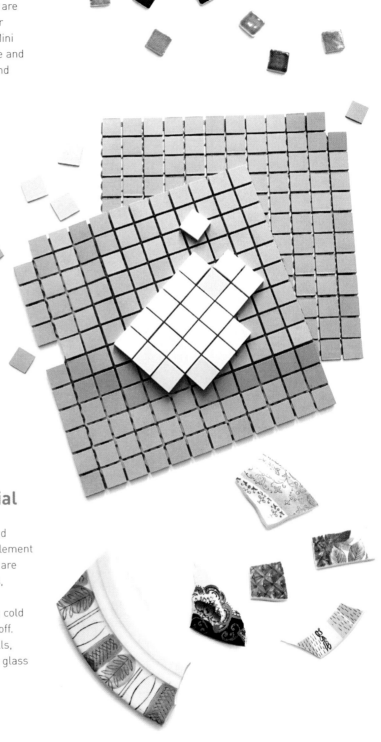

Glazed ceramic tiles

The range of glazed ceramic tiles is limited and if the glaze is domed they are difficult to use after they have been cut. Some tiles are not frost proof and, as they are all plain on the reverse face, they are not suitable for the indirect mosaic making method (see page 20). Mini porcelain glazed tiles measure 10 mm (3/8 in) square and are interesting to use because when laid together and grouted only the centre of the dome shows.

Unglazed ceramic tiles

Unglazed ceramic tiles are probably the cheapest of ready-made mosaic materials and come in an earthy, subdued range of natural colours in dimensions of 20 or 25 mm (3/4 or 1 in) square and 3 mm (1/8 in) thick. They are hard wearing, frost proof, easy to cut and are flat on both faces so can be flipped over. They have a completely matt surface, so make an interesting contrast when combined with the shiny vitreous glass tiles. They can be bought loose and in random colour mixes. Soaking sheets of ceramic tiles off paper mesh can be a fiddly and unsuccessful business – a handy tip is to 'cook' them overnight in a slow cooker (thanks, Rhonda of Mosaictrader)! Ceramic tiles are the only ones listed here that are suitable for heavy-traffic floor areas.

Broken china and other material

Unwanted or broken china is a perfect material for recycling for use in mosaic making. China be cut and shaped to incorporate in any mosaic, and adds an element of fun, surprise and humour. However, since glazes are not frost proof, china should not be placed outdoors, unless you are prepared to risk the mosaic to the elements. Smaller bits may escape the ravages of a cold winter, but be warned the glaze may crack and fall off.

In addition to old china, salvaged items like shells, marbles, rusty objects, coins, bottle tops and beach glass are all suitable for adding interest to a mosaic.

tools, equipment and surfaces

There is no need for a huge financial outlay on tools and equipment for making mosaics. You can buy most tools quite inexpensively and you may already have some in your toolbox at home.

Tile nippers

There are two types of nippers for cutting tiles: side biters – a widely available nipper you may find in the average home toolbox, and wheeled nippers, especially designed for mosaic making (the 'Leponitt' brand seems to be the gold standard). Both types are useful for the mosaicist, but if you are serious about mosaic, then the wheeled nipper is for you.

Long-handled side biters have the most leverage. Both the front and back square edge can be used, making them good for cutting tougher material such as marble.

Wheeled nippers are generally more precise and are therefore useful for detailed shaping, especially for glass.

The wheels can be turned when they get blunt and can eventually be replaced. You can also remove the pin from wheeled nippers so as to allow the jaws to open more widely, which might be necessary when cutting smalti bricks on their sides.

Glass cutters

Purchase either an economical score-and-snap cutter, or an oil-filled glass cutter for use with running pliers. The second option is easier to use but more expensive. Oil is stored in the hollow handle, a little of which is released on to the cutting line as you score, making for smooth, easy cutting.

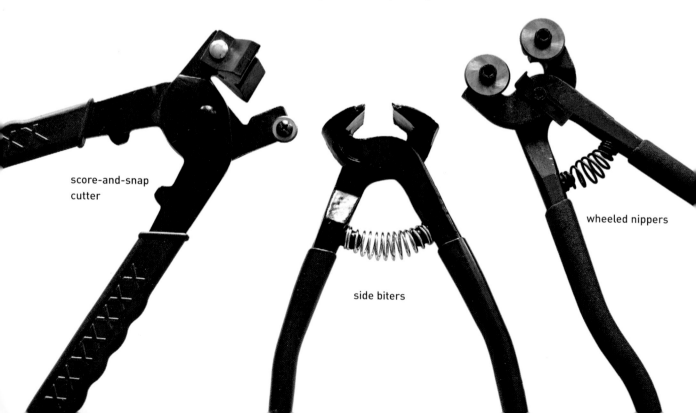

score-and-snap cutter

side biters

wheeled nippers

Other useful tools

- Craft tweezers for fiddly work, especially when working with tiny beads and tesserae
- Decorator's brush to keep the working area clear of tile fragments
- Craft knife for cutting brown paper and self-adhesive film
- Bradawl or similar pointed tool for tidying up work and picking out adhesive
- Notched trowel for applying an even layer of adhesive over large areas
- Small spreader for adhesive. You need some sort of spreader for applying adhesive to small pieces of work – a palette knife, plastic spatula or even an old credit card
- Grout float for smoothing adhesive or for applying an even pressure to the surface of your work
- Face mask, goggles and gloves for protection when cutting glass or breaking china
- Marking pens and pencils

Surfaces

With the right adhesive (see page 25) almost anything rigid can be used as a base for mosaic work.

Glass

Glass makes a useful base for mosaic projects because it is thin, strong and waterproof. It is particularly effective used with transparent and translucent tiles next to a light source and is often used to make light catchers. Use it in sheet form or purchase inexpensive glass items from homeware stores, such as vases, trays, tumblers, candle holders and lamps that you can mosaic. Use silicone glue when working with glass.

Mirror

Thin and strong like glass, mirror also has reflective qualities that are useful for mosaic work (see Glitzy Mirror, page 98).

Plywood

Plywood is a useful base but vulnerable to damp so prime it all over (faces and edges) with diluted PVA for indoor use. 'Marine ply' is supposedly impervious to water but never use it outdoors without coating the reverse face and edges at least three times with marine varnish (but not the face on to which you want to attach tiles). If a panel is to be fixed to a wall, seal all around the edges and fixings with black or transparent silicone sealant to prevent potential damp problems.

MDF (medium density fibreboard)

Regular MDF – use board at least 12 mm ($^1/_2$ in) thick – is very stable and inexpensive, but vulnerable to damp. Priming the faces and edges before use with diluted PVA offers some protection – even so, never use it outdoors. There is, however, a moisture-resistant version for external use. Again, don't trust it completely but prime and varnish as for marine plywood. Always wear a mask when cutting MDF.

Tile backer board (Wedi board)

Manufactured specifically for use in wet rooms and bathrooms, it is light, inexpensive and can be cut to size. If you are using it at a large size strengthen it with a frame made from wooden battens before you start mosaicing. The edges, however, are vulnerable.

Slate

Slate is an excellent base as it is waterproof and attractive in its own right. Old roofing slate is often discarded during house renovations and available in skips for the taking. Just ensure the face of the slate is stable as pieces can sometimes break away. 'Fake slate' available from any builder's merchant is also perfect for small mosaic projects that need to go outdoors, and is very easily cut to size with a craft knife.

Metal

Use one of the ready-made bases available from craft suppliers, find items like small tables from a homeware store or commission a blacksmith to make up a metal tray to take your mosaic (see Marble Fish Table Top and Al Fresco Table, pages 54 and 38).

Terracotta pots

Buy frost-proof glazed pots and provide a 'key' with diluted PVA. Seal unglazed pots with diluted PVA or a water sealant inside and out.

cutting tesserae

In order to make a mosaic, the pieces must be cut up – that may seem obvious, but the techniques for doing it are less so. Always wear a mask and goggles to protect yourself from tiny shards and dust.

Cutting tiles

The cutting operation is more of a squeeze – 'nipping' is probably a more accurate description. The manner of cutting depends on the nippers you have – wheeled nippers or side biters (see page 12). For both types, grip them near the end of the handle to get maximum leverage. Clamp wheeled nippers over the centre of the tile, and use the jutting edges of the jaws of side biters to take just a 'bite' out of the side of the tile. Use the back square edge of the side biters for cutting circles and curves, especially when nibbling unglazed ceramic tiles. Keep your fingers out of the way of the jaws and hold on to both parts of the tile, as they can go in any direction with some force. Until you've mastered applying the correct pressure, pieces fly all over the place, so it's a good idea to practise cutting inside a large clear plastic bag initially, to contain the pieces.

Watch out for small splinters that fall. If the tiles are of glass these will be sharp so resist the temptation to brush them away from your work with the side of your hand – always use a decorator's brush instead.

Half- and quarter-tiles

It is efficient to prepare a reservoir of tiles when working. The basic unit for much mosaic work is a quarter-tile cut from a 20 mm (³/₄ in) square tile, so start by preparing a supply of these. First cut the tile into two equal halves and then cut again to make quarters. Don't worry if they are not exactly even as this is what gives the mosaic a handmade feel. If one tessera is much larger than the others it will make your first line uneven, and the next one will be more so, unless you compensate for the larger piece by using a smaller one in the next line. Half-tiles can also be used but they are less adaptable; eighths are rather fiddly, will not sit flat and gather too much grout. Randomly cut tiles may be used, but think about the logic

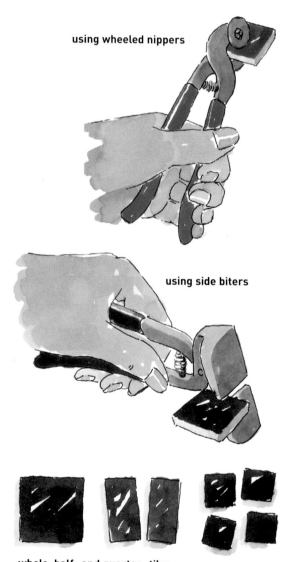

using wheeled nippers

using side biters

whole, half- and quarter- tiles

Cutting a whole circle from a tile

There are only so many shapes to play with in mosaic work and a circle is definitely useful. They are used extensively in this book. It is easier to cut a circle from a double-faced tile, i.e. one that is flat on both front and back. This includes Sicis tiles and unglazed ceramic tiles. Cut off the four corners then nibble the edges or small points until you have a neat circle. Vitreous glass tiles are a little more tricky because of their bevelled edges but do persist – it is simply a matter of practice.

of the shape and how they will work with the construction and flow of your mosaic.

Cutting china

China is not difficult to break but it can be unpredictable, so always wear goggles. For more chunky china use side biters – the back square edge can be really effective for nibbling shapes. Wheeled nippers are also useful but don't attempt anything too tough – you could break the blades! To break a plate, just place the front edge of the nippers on the edge of the plate and squeeze, it will usually break quite easily. Some people place the whole thing into a plastic bag first, in order to make the first 'cut' with a hammer. Once you have two pieces it is easy to start chopping interesting pieces out of the pattern. If your china is of different heights try and build up the slimmer pieces of china with some extra adhesive so it makes a reasonably even surface, or else use the indirect method.

Cutting stained glass and mirror

It's extremely easy to cut stained glass and mirror glass with an oil-filled glass cutter. However, it does produce extremely fine filaments of very sharp glass, so take care, wear goggles and use gloves. The very basic rules of glass cutting are to *pull towards you* when scoring a straight line on to glass, but *push away* from you for a wavy line. A second attempt at scoring a line is not always successful, so try and get it right the first time. Note: if the front surface of the glass is textured you may need to score on the reverse. To cut stained glass sheets into tesserae, score 10 mm (3/8 in) wide strips using a glass cutter. Exert a firm pressure so there is a grinding noise and go all the way, using a ruler as a guide. Even if you deviate from the line slightly, don't stop. Snap the strip off with running pliers (or use a score-and-snap cutter for the whole operation). Cut the strips into square tesserae with wheeled nippers.

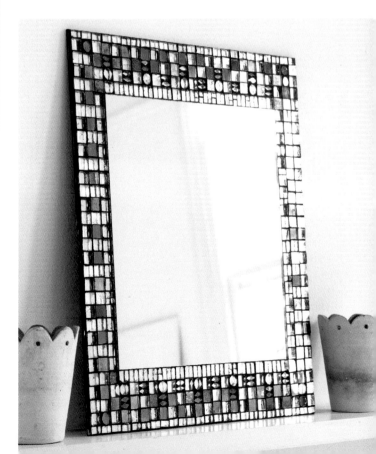

laying tesserae

When laying tiles think about the resulting grout lines as these are an integral part of the work. The size of the gap left between tiles (interstices) can be large or small but must be consistent as any careless gaps are soon highlighted by the grout. Some mosaicists work very tightly and don't grout at all but, generally, the tiles should be close without quite touching.

Straight lines and curves

Mosaicing in straight lines is relatively simple, but in order to make a curve you need to create wedge shapes, rather like those over the top of a Roman arch. To do this, simply turn the tile slightly on an angle when making the second cut, from a half-tile to a quarter. Soon you will have a little supply of shapes, which when placed in a line will allow it to curve. If the line is curving too much, place a regular square tessera to correct it. The angle of these cuts can be quite subtle, so at first glance it just looks like a gently meandering line. If you need to curve tightly, take a half-tile and cut off each end at an angle to create a trapezium – a series of these will slot together to make a circle.

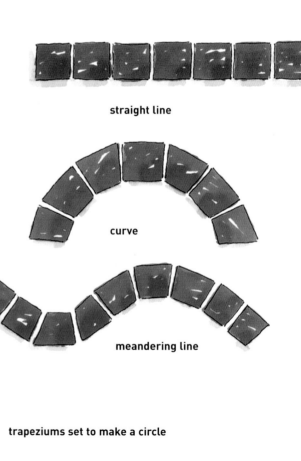

straight line

curve

meandering line

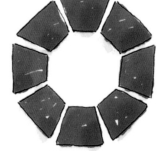

trapeziums set to make a circle

Grout lines

The *andamento*, or the flow of the piece – the mosaic equivalent to brushstrokes – describes the form of your mosaic. Rhythm and movement, created by the grout lines, are essential ingredients for mosaic work. Even though laying tiles is quite painstaking and deliberate, the design must be free and flowing. Regular lines covering the background are described as 'opus regulatum' or, if they are offset from adjacent lines, 'opus tesselatum'. 'Opus musivum' describes the pattern when the lines move out from the central motif like ripples in water and gives the mosaic a lively sense of movement. 'Opus palladianum', crazy paving, features irregular shapes – because it is random, it is good for beginners. 'Opus vermiculatum' tightly follows the profile of a central motif, echoing the features to help separate them from the background (see Al Fresco Table, page 38). You will have to decide which pattern will work best in your mosaic.

Using templates

Before laying any tesserae you first need to transfer your chosen design to the base to be mosaiced. To use the templates on pages 118–126, enlarge them using a photocopier or by hand, measuring and copying the design using graph paper to achieve the same proportions. You may then be able to transfer the design to paper or a wooden base using carbon paper, but you will have to copy it freehand on to bases made of metal, glass or ceramic. Use a non-permanent pen on metal and glass, a chinagraph pencil or felt-tip pen for marking glazed ceramic and a black marker pen when working with mesh.

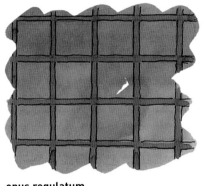

opus regulatum

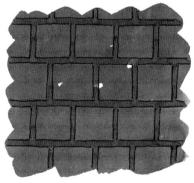

opus tesselatum

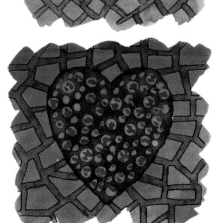

opus palladianum

opus musivum

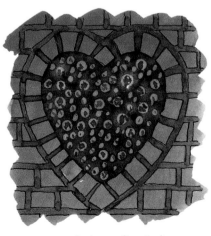

opus vermiculatum (border)

Choosing your pieces

Always concentrate carefully on the most visually predominant areas of your mosaic work. With borders, for example, always start neatly in the corners using regular tesserae. If any tiles need adjusting, choose a tile in a less noticeable position further along the border. Similarly, when working on the background, avoid any tiny tessera on the outside edges of the work where they meet the border, as they will be noticeable. If you have the choice between using two tiny tesserae (which together would gather a disproportional amount of grout) or one larger one to fill a gap, choose the latter. If it is difficult to judge the shape required for a particular gap, hold your tile over the space and draw a line on it using a non-permanent pen (on glass), a lead pencil (on unglazed ceramic) or a non-permanent felt-tip pen (on glazed ceramic). You can now nibble it to the correct shape, as marked.

Colour and character

A picture portrayed as mosaic is very graphic so you need to draw it as outlines, rather as a child would approach the subject. Every mosaic is unique by the way in which the tiles are laid, and the character of your mosaic will be determined by how you 'colour in' your outlines. The diagrams below show three different choices that might have been made for the birds on page 114. With mosaic you have to enjoy the restrictions of the medium and thrive on the stylization forced upon you by the limited choice of colours – there is no mixing or merging of colours as with watercolour paints for example. As a beginner, access to materials might mean you are forced to be very creative with the colours that you do have, but this can be a good thing! Divide your materials by colour into glass jars for storage and view them to consider hue, tone and contrast as you ponder the best choice for your project. As a beginner, it is best to opt for strong contrasts. Move on to more sophisticated combinations as you progress, selecting shades of the same colour, or a palette of related tones. Since mosaic tiles are made for swimming pools there are plenty of blues, greens, whites, blacks and beiges, but not so many shades of red, yellow, purple and pink.

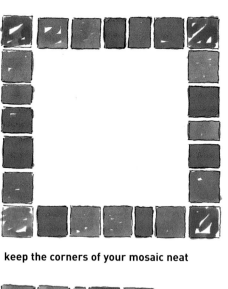

keep the corners of your mosaic neat

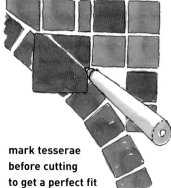

mark tesserae before cutting to get a perfect fit

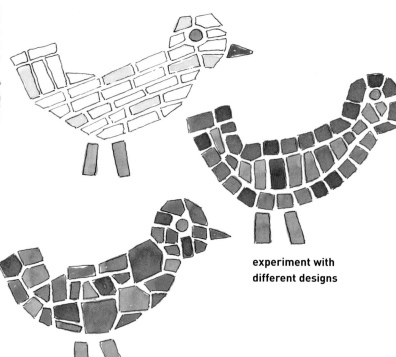

experiment with different designs

mosaic making techniques

There are two basic methods of making a mosaic – direct and indirect. The direct method is the most straightforward – tiles are laid the right way up straight on to a base so you can see the finished mosaic being built up as you work. The indirect method involves working in reverse and sticking tiles face down on to paper or film, later flipping the work over on to a bed of adhesive and revealing the front face of the mosaic.

Direct method

The direct method is essential for some three-dimensional projects (see Christmas Baubles, page 64) but is also used on flat surfaces where it doesn't matter whether the finished mosaic is a little uneven (see Kitchen Plaque, page 90).

Using mesh

This is a very useful method for any mosaic you cannot make on site as it allows you to work directly and then install the finished piece elsewhere, for example a garden wall or an inset within bathroom tiling (see Jellyfish Wall Tile Insert, page 94). It involves sticking tiles to a fibreglass mesh. You must back the mesh with polythene or the adhesive will go straight through the mesh and stick the work to the surface beneath – not very helpful if it is your table! The slight disadvantage of this method is that the coarseness of the mesh unbalances small pieces of tesserae. As always, do not cut the tiles over your work, or irritating little shards will fall between the mesh and the polythene.

1 Draw the design to the required size, using a black marker pen so that the lines can be seen through the polythene and the mesh. Place the drawing on the work surface, then lay some polythene over it, making sure there are no creases in it. Secure the polythene and lay the mesh over the top, leaving a margin of mesh at the edges. Fix the mesh in place, although the PVA used to fix the tiles will soon stick the mesh firmly to the polythene.

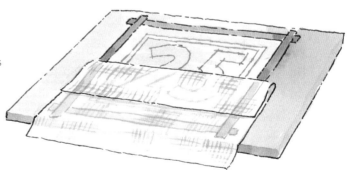

2 Stick tesserae on to the mesh.

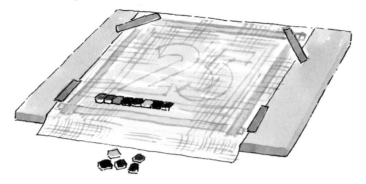

3 When the work is finished leave it until the PVA has dried enough to be stable. Then carefully turn the work over and peel off the polythene, exposing the PVA on the back that hasn't dried. Leave this aside until all the PVA has turned clear. (There is a slight danger with this method that the PVA will prevent the tiles making good contact with the adhesive. If the PVA is coating the tiles completely, expose the back of the tiles by breaking up some of the PVA using a craft knife or bradawl.)

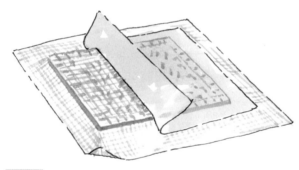

4 Carefully cut away the excess mesh at the edges of the mosaic. It is now ready to install.

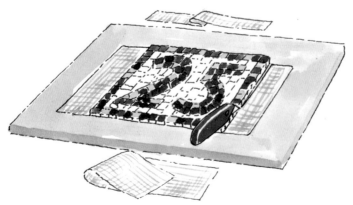

Indirect method

The indirect method involves sticking tiles face down, so the design is reversed, either on to brown craft paper using a weak solution of glue to secure the tiles, or on to self-adhesive film. When completed, the mosaic is flipped over and set into a bed of adhesive so that the finished surface, now uppermost, is completely flat (essential for a table surface). The face of the mosaic is exposed by removing the brown craft paper or self-adhesive film from the tiles, and the mosaic is then grouted.

The indirect method is the best way to achieve a flat finished surface if your tesserae are of different heights (see Lovebirds Wedding Plaque, page 114). Another advantage is that it is possible to remove and alter parts of the mosaic if you change your mind while you are still working on it as the diluted adhesive or self-adhesive film is not particularly strong.

The indirect method also allows mosaicists to execute a commissioned mosaic at the workshop and then transfer it to its final site when complete.

With the indirect method the *best* face of your tile must be stuck *face down* as this will be the front face of your mosaic. Be aware that a cut tile may have a neat break on one face but appear ragged on the other.

Using brown craft paper

Brown craft paper is most commonly used for the indirect method. It tends to have both a smooth and a ribbed face – stick tesserae to the ribbed face only. (Craft paper is also sold gummed, the same paper that is used on sheets of vitreous glass tiles.)

1 First wax the board behind the area of the brown craft paper that will be mosaiced. Otherwise the glue may seep through the paper and attach your mosaic to the board – a mistake you make only once! Do not wax the whole board or you will not be able to stick on the gummed strips to secure the brown paper. Now you need to stretch your brown craft paper so that it does not wrinkle when the glue is applied. Wet the paper, smooth it on to the waxed board and secure it with wetted gummed paper strips (available from art suppliers). Allow it to dry and you will have a taut working surface. If you do not stretch your paper, the glue may cause your paper to shrink a little and, if the tiles are very close together, they will end up touching.

2 Transfer your reversed design to the brown craft paper and make up the mosaic, sticking the tesserae face down on to the paper. For adhesive, use either diluted PVA (ratio 50:50) or, if the material is uneven like broken china, use wallpaper paste that has more body to 'grab' the pieces.

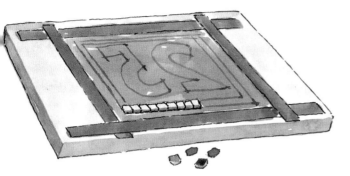

3 When your work is complete, spread suitable adhesive on to the mosaic's final site. Comb it with a notched spreader (unless it is PVA, which is too runny). Pregrout the mosaic to prevent the adhesive coming up through the tiles. This is done in exactly the same way as normal grouting (see page 26) but work quickly as the paper will start to disintegrate after about 15 minutes, causing the tiles to drop off when the mosaic is lifted up. Place the grout on the back of the tiles, squeeze into the gaps and then clean up the back of the tiles or the adhesive will not be able stick to them. Use a very well-wrung sponge or you will soak the paper. If the back of the work is uneven, butter the recessed areas with some adhesive, or the thinner areas will dip when you turn the mosaic over. This is only usually necessary when working with china or marble, which tend to be of varying heights.

4 Turn the mosaic over and, holding opposite corners, line it up very carefully with the base. Lower the mosaic on to the bed of adhesive – it can be helpful to have another pair of hands at this stage.

5 Make sure all the tiles are in contact with the base but do not press down with your fingers or you will put dents in the mosaic. Use a flat object like a grout float to press down evenly over the whole surface. Dampen the paper thoroughly with a sponge and leave for 10–15 minutes – re-wetting if it starts to dry out.

6 Peel off the brown paper, starting from one corner of the mosaic. If the paper comes away easily continue peeling it back until halfway and then turn the mosaic and peel from the opposite corner. Ease it off gently in case any tiles detach (tiles are most likely to detach from the edges), pulling the paper back on itself.

7 If any tiles come away, add a bit of adhesive and push them back into position. When the paper has been completely removed apply some adhesive around all the outside edges to secure these more vulnerable tiles. Before the grout dries on the front of the mosaic, carefully clean up any that has spread on to the face of the tiles using a damp cloth. The adhesive is still soft so don't handle the mosaic unnecessarily.

8 When the adhesive is completely dry, regrout for a perfect finish.

Using self-adhesive film

Self-adhesive film is useful for small mosaic projects (see Chillies Tray, page 42) and where the tesserae are flat and not too tiny to stick to film. The technique does not allow constant repositioning as you design your mosaic, so it is best to work out difficult areas before you commit them to the film. It can be useful, but not essential, to have a can of spray adhesive to hand, which provides extra adhesion for individual tesserae if the film starts losing its tackiness.

1 Place the drawing on your work surface, remembering to reverse the design. Cut a piece of self-adhesive film that is slightly larger than the template and place it, sticky side up, over the drawing. Peel back a few centimetres of the backing paper on one side, fold it out of the way and stick the film down with tape, all the way along.

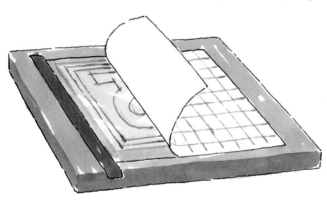

2 Then peel off all of the backing paper (saving this paper to protect the mosaic when it is not being worked on) and stick the film down all the way around the edges. The film should be totally flat and unwrinkled. Do not cut tiles over the film or the little shards will stick to it. Place tiles directly on to the sticky film.

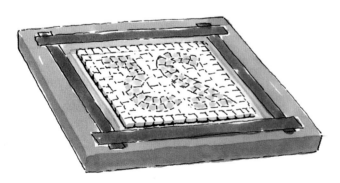

3 When the mosaic is complete it is ready for installation. (If you have used uneven tesserae, pregrout the mosaic (see page 21) and set it into a bed of adhesive, removing the film and tidying the grout from the front face after 15 minutes or so. Wait 24 hours before grouting again.) Alternatively, if all your tesserae are of the same height, there is no need to pregrout. Using a craft knife, cut all the way around the outside of the mosaic through the film, to release the mosaic from the work surface. Place the mosaic straight on to a 1 mm (1/16 in) bed of PVA and leave overnight.

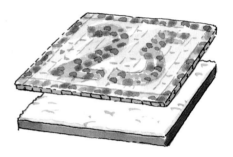

4 The next day remove the film and grout the mosaic in the normal way (see page 26). If the PVA is taking a while to dry, puncture or slit the film to allow air through to hasten it along.

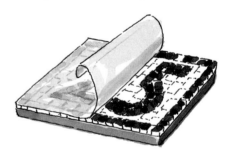

5 Use tougher polythene for larger or heavy mosaics (see Marble Fish Table Top, page 54) and fix the tesserae face down with spray adhesive. Using spray adhesive allows the tiles to be repositioned many times but you do need to wear a protective face mask and make a spray booth to protect your working area. To do this, build up the sides of a cardboard box and place the tiles inside this when coating them with spray.

glues and gluing

A mosaic takes a long time to make and is very hard to undo – indeed impossible after it has been grouted – so spend time at the planning stage and try and get it right first time. Experiment with cutting and laying the tiles before you fix anything, decide whether your mosaic will be situated indoors or out and choose your adhesive accordingly.

Sticking tesserae

The usual order for sticking is to glue the central motif in place first, then the borders and finally the background. Do not cut and lay out too much in advance as the tiles will only need lifting again. Unglued, they are vulnerable to movement and often they don't piece back together as you planned anyway.

Start with an important line of the picture or pattern, cut five or six tesserae and then stick them, either by lifting the individual tiles and buttering them on the back with adhesive, or by laying out a line of glue to receive them. Craft tweezers are really useful for this task. Do not allow glue to dry on the base, especially PVA, as it dries hard into a bump. It can be helpful to dispense tile adhesive through a disposable piping bag (the type used in cake decorating) as you can then place the glue exactly where it is needed, so it is less messy. To stop the adhesive going off during work breaks, just tape up the end of the bag or use a clip. Disposable piping bags are no good with PVA as the glue is too runny.

Keep an eye on your mosaic work until the adhesive is set as pieces tend to get knocked or forced slightly out of position by new tiles. Use enough glue, in the first instance, to enable the repositioning of these tiles.

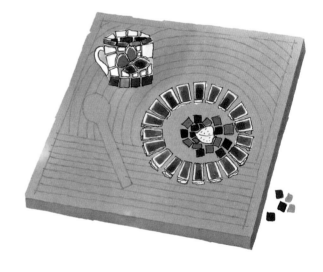

begin by sticking the central motif first

Types of glue

The adhesive required for each project will depend on whether the mosaic is going to be situated indoors or outdoors. Always read the instructions very carefully as to which adhesive is suitable for which substrate and how long the adhesive takes to set.

PVA (polyvinyl acetate)

PVA is a water-based white glue, which sets clear and has a very strong bond. Use it for indoor direct mosaics. It can also be diluted with water (ratio 50:50) and used to seal porous surfaces. Use good-quality PVA, the type sold in builder's merchants. PVA cannot be used for external projects or for vertical surfaces as it does not have enough body to stop tiles sliding down in response to gravity. Weldbond is a type of PVA that is good for fixing glass to glass, it dries clear and has a very strong bond.

Tile adhesive

Buy tile adhesive in powder form – generally available in white or grey. Bal and Mapei are both good brands. If you like you can add cement stain (available from builder's merchants) to white tile adhesive to alter the colour to match the grout. If your grout and adhesive match in colour it eliminates the situation where if you have not cleaned up the adhesive sufficiently, peaks of it show though the grout. If you choose not to stain the adhesive, just make sure you work carefully and clean up as you go along.

White adhesive is best with transparent tiles as it emphasizes their translucent qualities. Mapei's Ultramastic (white) ready-mixed tile paste sets quickly and can be grouted in just a few hours. However, it sets *very* hard so be sure to remove excess adhesive before it dries – just as it is starting to crumble is a good time.

Exterior-grade flexible adhesive

BAL Flex is a trade name for a two-part rubbery adhesive that never sets completely hard but remains spongy. This is useful where flexibility is required, for instance when setting into a metal tray that may move with the elements. It is also excellent for working vertically.

Two-part epoxy resin

This is a strong and weatherproof adhesive, useful for repairing outdoor mosaics.

Silicone glue

Silicone glue comes in a tube and is used for 'glass on glass' projects. Unfortunately it is rather unpleasant to work with. Use it only in a well-ventilated room and dispense it straight from the tube, trying not to get it on your fingers as it is hard to remove. Have lighter fluid or 'sticky stuff remover' to hand to help deal with the stickiness, but even this is not ideal. It is far better to work very carefully and get the glue only where it is needed. It has a working time of only 10–15 minutes.

To use silicone glue, use tweezers to set glass tesserae firmly into the adhesive so that all the air is pushed out and there are no bubbles beneath the tile. The whole base of the tile must be bedded in the adhesive, otherwise grout may later seep behind the tile and be visible. Also ensure the adhesive does not rise up between the tiles, or the grout (which is usually black grout for 'glass on glass' projects) will be interrupted with peaks of transparent glue. When the adhesive has cured, spend some time with a bradawl or similar tool picking out any excess from between the tiles before grouting.

It sounds more tricky than it is, but don't be put off using silicone glue.

Polyurethane glue

This is similar to silicone glue above and you should avoid getting it on your fingers, but it has no fumes and a slower drying time.

grout and grouting

Grouting is the practical process of filling the interstices, the gaps between the tiles. It is the point of no return so make sure you are happy with your work before applying grout as there is no going back! Grout comes in a variety of colours and coarseness and should be carefully considered before it is applied as it has a major influence on the final look of the work.

Grouting

Mosaics in locations that need to be waterproof and easily maintained must be grouted. Some decorative mosaics where the tiles are butted closely together may be left ungrouted, particularly when smalti is used (see Zingy Laundry Box, page 80).

Depending on the size of your mosaic, allow a good half-hour without interruptions for grouting. It is a messy business so wear an apron and gloves and protect all surfaces. Outdoor mosaics using dark grout should be kept inside for two or three days after grouting to allow the grout to cure as it will stain if exposed to rain.

Glazed tiles

1 Using a decorator's brush, dust over your mosaic to remove any fragments of tesserae and to check that all the tiles are still stuck down. Glue any loose ones with a little PVA at this stage. Wearing a mask, mix the grout powder with water to the consistency of toothpaste.

2 Take a handful of the mixed grout and start to cover the mosaic, working the grout into the crevices. Use a grout float for this if you have one, but gloved fingers work equally well. Pay close attention to the edges and corners of the mosaic, working the grout well under the edge tiles. Run your finger down the sides or use an old knife to smooth the edges.

Grouting tools

- Disposable gloves (tough latex gloves or rubber gloves) and apron
- Old paintbrush
- Face mask for protection when mixing grout
- Grout float
- Old knife
- Soft cloth for polishing
- Grout sponge, which is denser than domestic sponges, and can be used on all faces
- Bradawl or similar pointed tool for tidying up grout and picking out adhesive
- Wire wool for cleaning up

3 Remove as much grout as you can with your fingers, or a float, then sprinkle with dry grout powder to absorb any excess moisture and to fill in any pin hole bubbles that sometimes occur.

4 Leave for 10–20 minutes and then rub with wire wool – the surplus grout will come away. If it is not cleaning up easily leave for another 5 minutes, then try again.

5 Check that any beads, millefiori or shallow tiles are all visible. Excavate them using a pointed tool at this stage if necessary as it will be too late once the grout has dried. Finally, polish with a soft cloth.

Unglazed tiles

Unglazed ceramic tiles do not like to sit around with grout on them, so follow Steps 1 and 2, then clean up straightaway as follows.

1 Using a damp grout sponge, start wiping across the mosaic. Your sponge should be well wrung out or you will flood the grout out of the gaps. Use a clean face of the sponge for each stroke, and wring out the sponge in a bowl of water when every face of the sponge has been used. Remember one wipe, one wring – otherwise you are just putting the dirty grout back on to the work. (Don't tip

this water down the sink, as the grout will clog the drain – pour off the surplus outside and scrape the sediment into the wastebin.)

2 Your mosaic will quite quickly start to be revealed, just keep going until it is completely clean. Don't forget to excavate low-lying tiles or millefiori. Again, polish with a soft cloth after an hour or so.

3 Any residue of grout that remains on the tiles or has stained the tiles can be removed with vinegar, diluted hydrochloric acid or cement cleaner. (The latter is available from builder's merchants – wear protection and use according to the manufacturer's instructions.)

Grout colours

Powdered grout comes in a basic range of colours: white, shades of grey, brown, beige, charcoal and deep black, and you can mix a combination of these, to make up a tone that suits the work. If you're not sure which colour to use, make up a small part of your work and experiment with different grout colours. All have a different effect on your work. White can look very stark. It can be a good choice if a lot of white tiles have been used; however, it will break up the dark ones, making that part of the mosaic hard to read. Grey is neutral and tends to unify. Black is more dramatic and brings out the intensity of the colours. It also gives a 'stained glass effect', outlining each tile with a line of black. If you like the look of a mosaic before it is grouted, the chances are you will like the look of a dark grout as it replicates the unfilled dark shadows of the interstices. Black grout emphasizes the *andamento*, the flow of the mosaic (see page 17) – be sure this is what you want to achieve.

Coloured powder can be added to white grout, to create purple, yellow, green or blue grout among others. In almost all cases this distracts from the natural beauty of the materials and overwhelms the design so is probably best avoided.

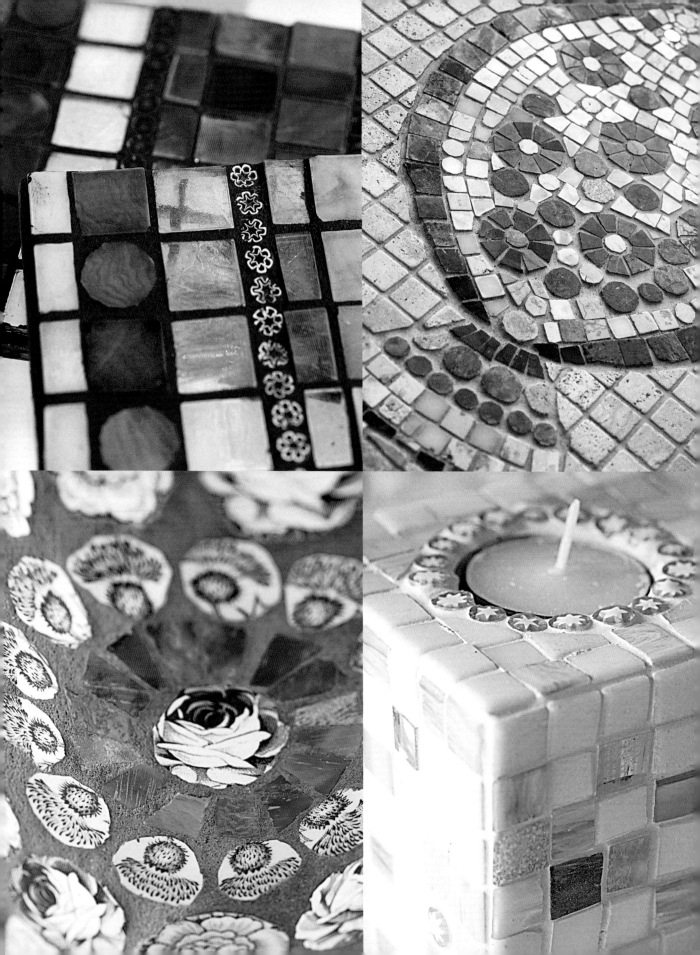

table décor

tools and materials

Pencil and paper

4 squares of glass or perspex, 100 mm (4 in) square,
 with ground edges for safe handling

Silicone glue

Old credit card or an adhesive spreader

Craft tweezers

Bradawl or similar tool

Black grout

16 plastic 'feet' (available from do-it-yourself stores)

mosaic pieces per coaster

Sicis Waterglass, Iridium, Glimmer and Murano Smalto tiles:
 35 in various colours

Millefiori: 15–20 in coordinating colours

This set of coasters in brilliant colours is easy to make. The challenge is selecting just four colourways from the extensive and irresistible Sicis range. Mounting Sicis tiles on glass emphasizes their translucent and iridescent qualities as they glimmer and shine against the contrasting black grout. Get a glass merchant to cut the glass bases for the coasters and grind the edges. Alternatively, look out for ready-made options in glass or perspex in homeware stores.

dotty coasters

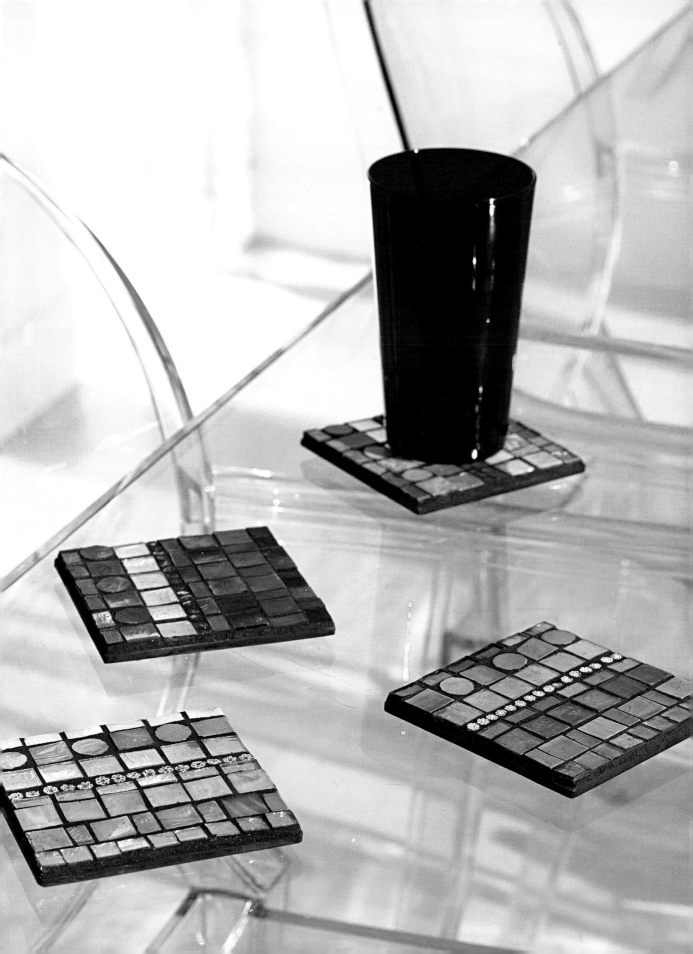

1 Copying from the photograph on page 31, draw the design on a sheet of paper then place your template under a glass base.

3 Using tweezers, set the tiles and millefiori firmly into the adhesive so that all the air and bubbles are pushed out.

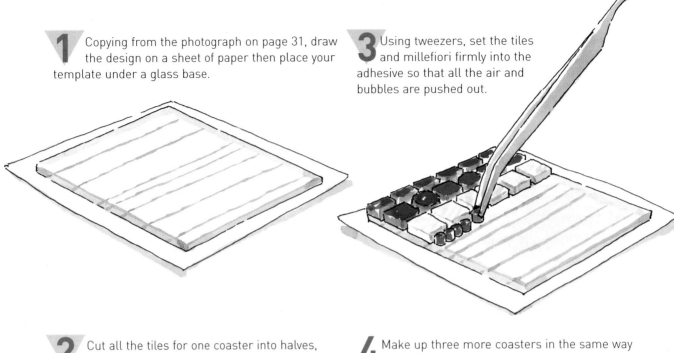

2 Cut all the tiles for one coaster into halves, quarters and circles and lay them out to make sure they fit the design. Squeeze silicone glue (see page 25) on to the coaster then, using an old credit card, spread it over the whole surface of the coaster.

4 Make up three more coasters in the same way then leave them for 24 hours until the adhesive is cured. Spend some time picking out any excess adhesive from between the tiles using a bradawl, then grout (see page 26) using black grout. Leave to dry.

5 To finish, mount plastic feet in the corners beneath each coaster to make them easier to pick up.

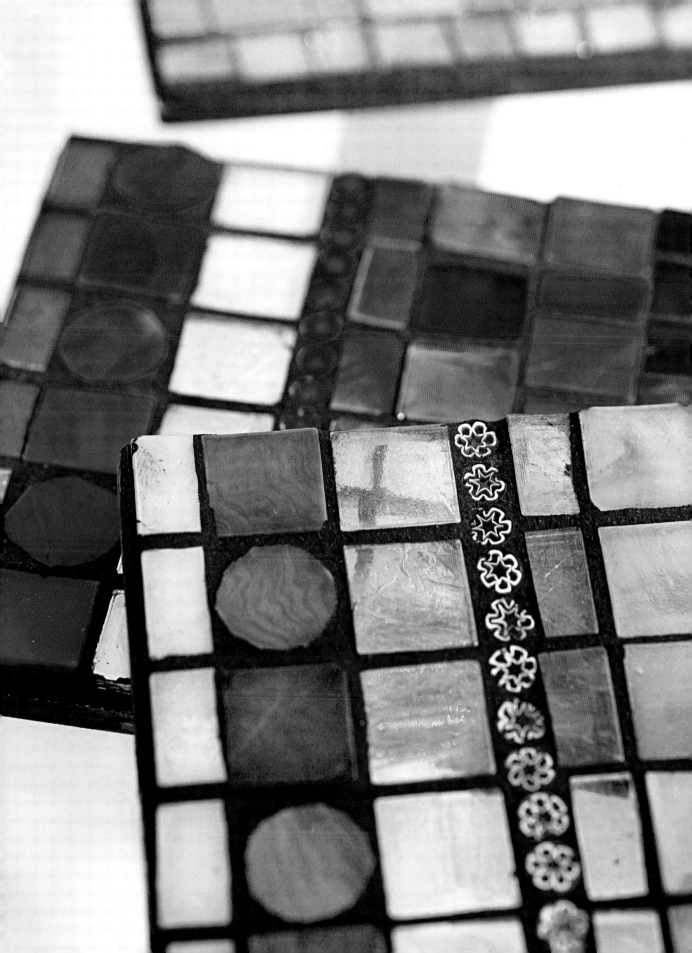

tools and materials
Vase, 250 mm (10 in) tall
Diluted PVA and paintbrush
Disposable piping bag
Tile adhesive, stained grey (see page 25)
Bradawl or similar tool
Chinagraph pencil or felt-tip pen
Grey grout
Felt pad

mosaic pieces
Mexican smalti: 50 pink/red
Old china: pieces of broken china in
 2 or 3 different designs

It may seem a disaster when you break a favourite plate or vase, but save the pieces and make something else even more special. Collect further items from charity (thrift) shops until you have enough mosaic material for your project, then choose a vase to cover and make a unique container that holds not just flowers, but special memories, too.

floral vase

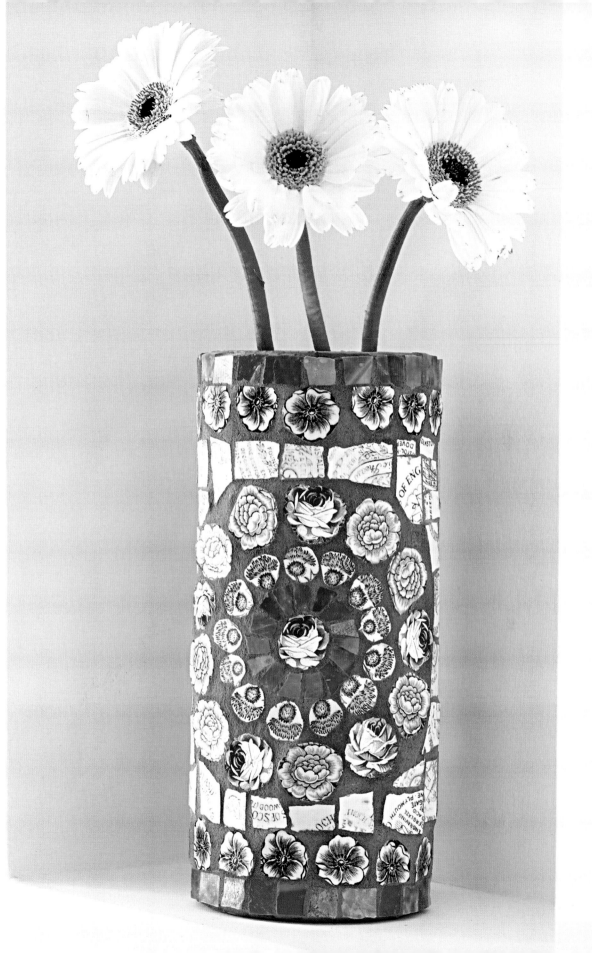

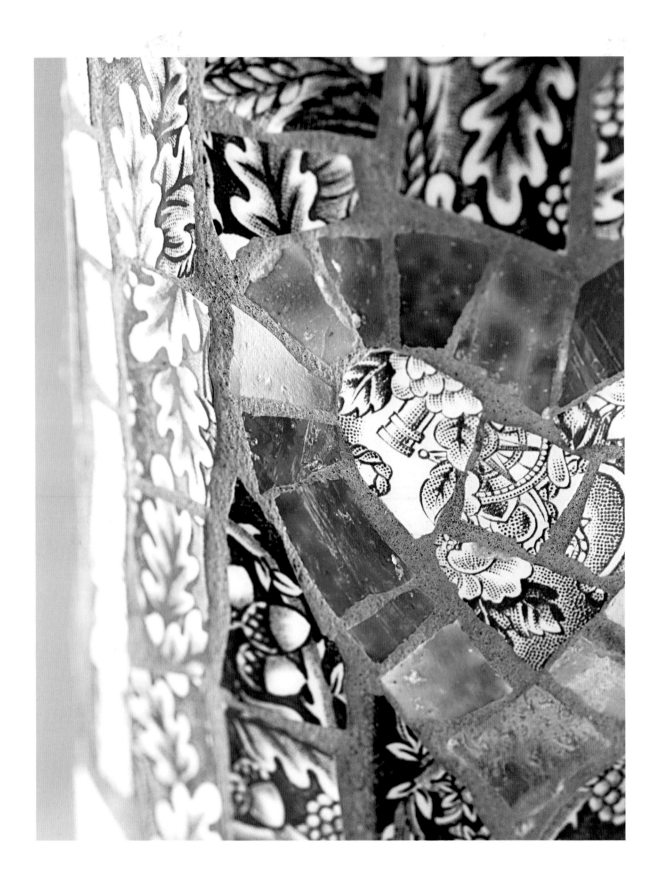

1 Prime the outside of the vase with diluted PVA.

2 The top and base edges of the vase are potentially a problem to finish off satisfactorily with china, so Mexican smalti are used for the borders because (unlike Italian smalti) the tesserae are all the same height. Using a disposable piping bag, apply adhesive to each piece of smalti. Stick the pieces neatly, just set in from the edge, around the top and bottom of the vase.

4 Choose a central feature for your design and draw the outline on your vase. If you want a motif both front and back, simply turn the vase around and create a new design. Lay the pieces of china out to the side of the vase first, to see how the design is working and to make sure you have enough china to finish. When satisfied, start sticking the pieces for the central feature in place first and working outwards. If you are using a variety of material with different heights, try and build up the slimmer pieces of china with some extra adhesive to make a reasonably even surface. If the surface pattern of the china is very busy, as here, define the central feature with more Mexican smalti.

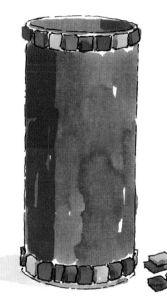

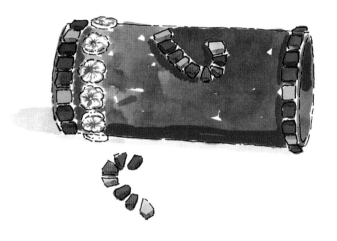

3 Next, stick a repeating feature of broken china, like the blue flowers used here, in a line next to the smalti borders. Set aside to dry for a while, scraping away any excess adhesive with a bradawl before it dries and hardens and becomes difficult to remove.

5 Finally, fill in all the background with the rest of the pieces of china. Leave for 24 hours before grouting (see page 27). Because the gaps between pieces are quite large you may be surprised how much grout is needed. The bottom edges of the vase need special attention because you don't want rough edges scratching your table top. Stick a felt pad on the base of the vase to help prevent this.

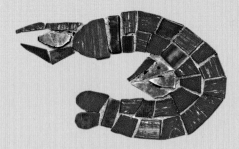

skill level

☐☐☐☐

tools and materials

Old treadle sewing machine table
Metal tray, 760 x 400 mm (30 x 16 in) (see page 40)
Template on page 118
Black marker pen and paper
Polythene
Piece of fibreglass mesh, larger than the metal tray by
 10 mm (3/8 in) all round
PVA glue
Exterior-grade flexible adhesive (BAL Flex)
Grout float
Black grout, for background
Grey grout, for plate

mosaic pieces

Old china: 2 plates (doesn't matter if they are slightly
 different), for mosaic plate; a leaf cut from china, for
 herb garnish
Vitreous glass tiles: 30 orange, for prawns; 2 black iridescent,
 for prawn eyes; 10 white/gold for wine glass;
 320 blue/green, for background; 20 greeny/orange for edge
 of tablecloth; 10 gold for tablecloth fringe
Antique gold mirror tile: offcuts, for cutlery, including 1 long
 piece, 10–15 cm (4–6 in), for knife blade
Sicis Waterglass tiles: 12 clear, for cutlery handles
Millefiori: 72 small gold, 4 large gold, for cutlery;
 1 large white, for wine glass; 50 small for edge of
 tablecloth; 8–10 large (or use clusters of smaller ones),
 for tablecloth fringe
Sicis glass tiles: 10 brown/red for wine glass; 20 orange for
 edge of tablecloth
Unglazed ceramic tiles: 40 speckled cream, cut into quarters,
 for table corners

Find an antique treadle sewing machine table and replace its wooden top with a weatherproof metal tray. Make your mosaic on a mesh (see page 19) and set it into the tray to create the table top later. This direct method of working is still practical enough to make a great occasional table for the garden.

al fresco table

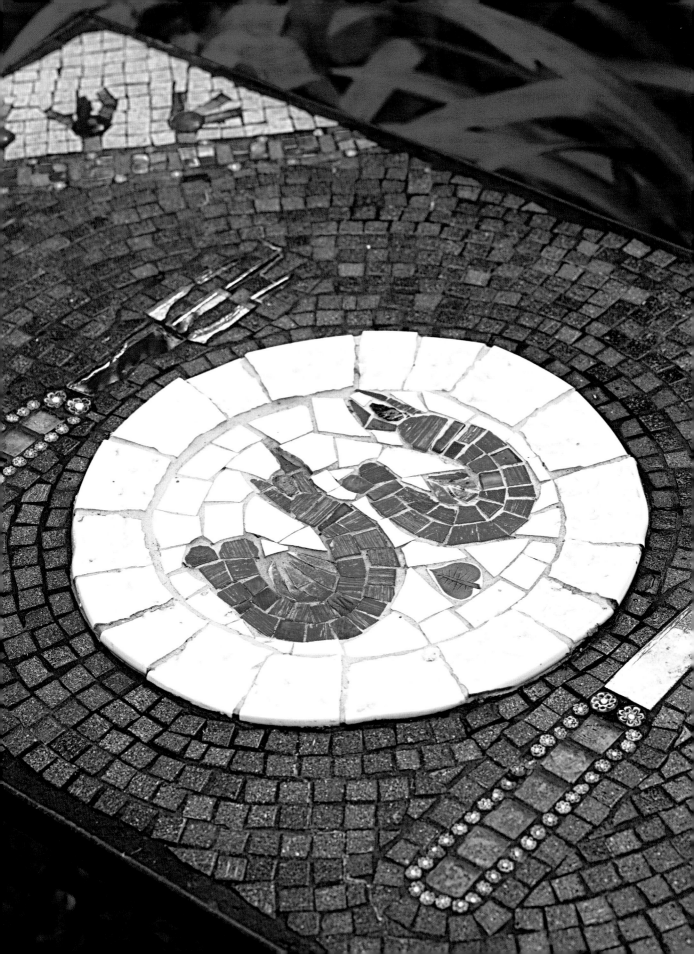

Remove the original wooden top on the old treadle sewing machine table. Get a local blacksmith to make up a metal tray and attach it to the cast iron legs instead. Alternatively, use some other suitable table. The sides of the tray/table top need to be deep enough to accommodate the depth of the tiles as well as the adhesive.

1 Using the template on page 118 and a black marker pen, draw the design for the table top to the required size on a large piece of paper. Place the drawing on your work surface, cover with polythene and lay the mesh over the top (see page 19). Tape to secure.

2 Start by cutting enough pieces from the edge of an old china plate or two (see 'Cutting china', page 15) to make up the rim of the mosaic plate. Glue the pieces in place on the mesh using PVA.

3 Next glue the orange vitreous glass tiles for the prawns, black iridescent tiles for their eyes and a leaf cut from china, for a herb garnish. Fill in the base of the plate around them using more of the pieces of china.

4 Cut the antique gold mirror (see page 15) into pieces to represent the metal of the knife and fork and glue in place. Create their handles using Sicis Waterglass tiles, small gold millefiori around the edge and 2 large millefiori at the end of each handle. Mosaic the wine glass using 10 brown/red Sicis tiles and 10 white/gold vitreous glass tiles and a single large millefiori.

5 Define the knife, fork and glass by outlining their profiles with a line of blue/green vitreous glass background tiles. Laying tesserae in this way, called 'opus vermiculatum' (see page 17), helps to separate these features from the background.

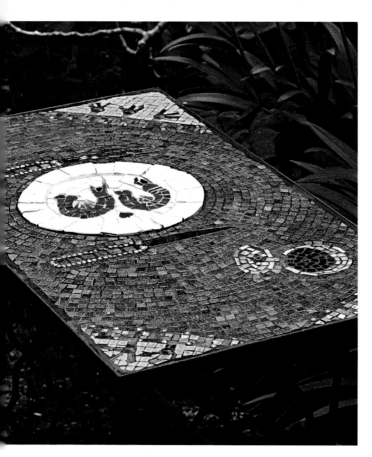

6 Continue laying the blue/green background tiles, neatly working outwards from the plate in rings, like ripples in water, 'crashing through' the main features.

7 Work up to the border and the edges of the 'tablecloth', avoiding using tiny pieces along the edges. Mosaic the four corners of the design using orange and greeny/orange glass tiles and small millefiori for the edge of the tablecloth, gold vitreous glass and large millefiori for the fringe, and quarters of cream unglazed ceramic tiles for the table corners.

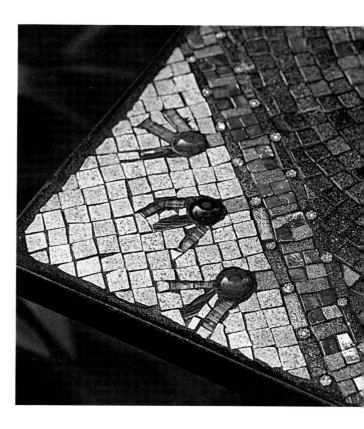

8 Leave to dry. When the PVA has dried enough to be stable, carefully turn the work over and peel away the polythene, exposing the PVA that hasn't dried. Leave to complete drying, then trim the excess mesh (see page 20).

9 Mix exterior-grade flexible adhesive and spread evenly into the metal tray/table top, leaving enough space for the tiles to be flush with the top edge of the table. Have someone help you turn the mosaic to the front once more and place it gently on to the bed of adhesive. Level the mosaic using a flat object like a grout float. If any adhesive squeezes up through the mesh, remove it before it sets (although it will not set completely hard). Let the adhesive dry thoroughly, according to manufacturer's instructions, before grouting (see page 26).

10 Grout the plate first with grey grout, then mask off the plate and grout the rest of the mosaic with black grout. Keep the table inside for a few days to allow the grout to cure as it will stain if exposed to rain too early.

tools and materials

Black melamine tray, 350 x 250 mm (13³/4 x 10 in)
Surface primer and paintbrush
Craft knife
Template on page 123
Pencil and paper
Tape
Self-adhesive film
Board
Spray mount (optional)
Craft tweezers
Lead pencil
Black grout
White tile adhesive
Notched spreader
Grout float

mosaic pieces

Vitreous glass tiles: 30 brown and dark brown, cut into
 quarters, for border; 30 assorted red, for chillies
Antique mirror or gold mirror tiles: 2–3, for border
Red stained glass and Sicis glass tiles: offcuts, for chillies
Millefiori, the same height as the other tiles: 8–10 red (choose
 carefully to find a few with a very flat face)
Sicis Iridium tiles: 6 green, for chilli stems
Unglazed ceramic tiles: approx 100 white and cream,
 for background
Old china: selection of pieces featuring patterns or 'back
 stamps' (the manufacturer's stamp on the back of plates),
 cut into 10 mm (³/8 in) squares

A small tray is a practical item for a kitchen. This one is so attractive it can be propped up as a picture when not in use. Using the indirect method here with self-adhesive film (see page 22) ensures the finished surface is completely flat – an essential requirement for a tray. Make life easy by sourcing slim pieces of china so that the differences in height are manageable.

chillies tray

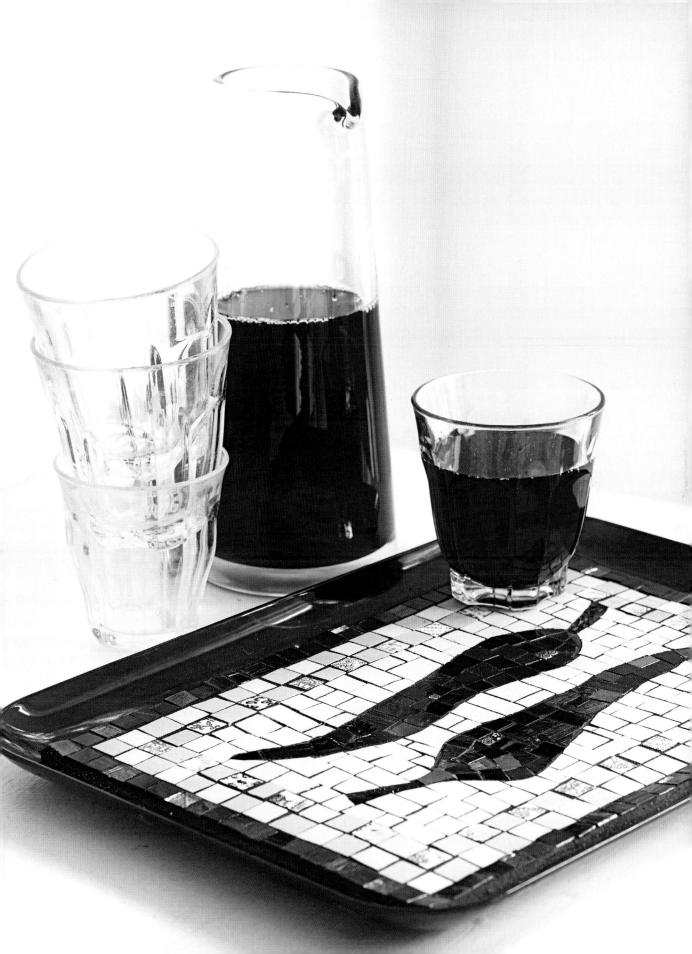

1 Since melamine is very shiny, prime the area to be mosaiced with a surface primer to provide a 'key' for the adhesive and scratch with a craft knife.

2 Trace the chillies template on to a sheet of paper to fit the tray – remembering your mosaic will appear as a mirror image (although it's not too important in this instance). Tape the drawing and a piece of film, sticky side up, to a board as described on page 22.

3 Start by laying the brown border tiles, interspersed with a few antique mirror or gold mirror tiles, placing them face down on the film. For efficiency work from a supply of tiles you have already cut. Avoid tiny pieces; if the pattern does not quite work out, use a few 'large quarters'.

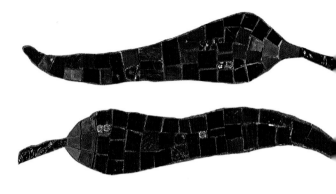

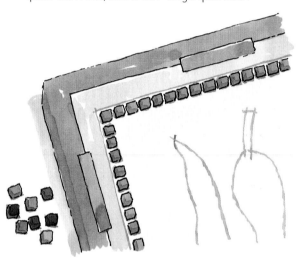

4 Next, lay the pieces for the chillies, again face down. Use lots of shades of red for the chillies, including stained glass, Sicis tiles, vitreous glass tiles and the occasional millefiori. The outside edge is the important part of the chilli – if there is any unevenness in the middle it won't be noticed, so work neatly to the keyline for the edge of the chilli and the stem, cutting pieces as you work. Use green Sicis Iridium for the chilli stems with some stained glass.

5 When the chillies are complete, work on the background. For the first background row lay alternate white and cream unglazed ceramic tiles, cut into 10 mm (3/8 in) squares.

6 For the second row, alternate squares of cream unglazed ceramic with squares of patterned or stamped china. If it doesn't work out exactly you may have to use two unglazed ceramic pieces together somewhere. Trim the china to size, or to a little larger than the required size until you are exactly sure of the gap that needs filling. Lay out these pieces of china on your work surface first to get an even distribution of colours, because once they are stuck face down, all that is visible is the colour of the plate they were cut from (usually white).

7 Fill in the rest of the background using the white unglazed ceramic tiles. Work across the tray in rows, varying the tile sizes to create more interest. Where pieces butt up to the chillies, hold a tile over the mosaic and mark it with a lead pencil (see page 18) to determine where to cut it.

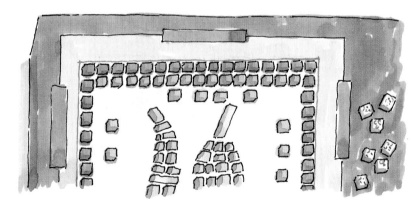

8 Because your tesserae are of different heights, pregrout the mosaic (see page 21) with black grout before transferring the mosaic on to the tray. Using a craft knife, cut all the way around the outside of the mosaic through the film to release the mosaic from the board.

9 Mix the adhesive to a stiff consistency – white adhesive will make the millefiori/red tiles appear brighter. Spread it over the area of the tray where the mosaic will sit using a finely notched spreader. Turn the mosaic over and place very gently, film side up, on to the bed of adhesive. Gently press the thicker china pieces to meet the surface of the tray. The thinner pieces will be supported by the thickness of the adhesive.

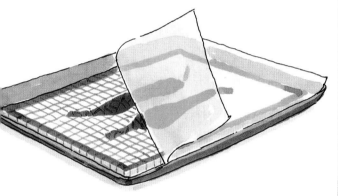

10 Use a grout float – not your fingers – to press down evenly over the whole surface (see page 21).

11 Leave for 15 minutes to give the adhesive a chance to stick to the tray, then gently ease away the film. Examine the mosaic, carefully scrape away any grout that has crept on to the face of the tiles using a fingernail, then leave to dry. The mosaic is very vulnerable at this stage so do not to disturb it unnecessarily. Leave the adhesive to harden completely, perhaps overnight.

12 After 24 hours grout again in the normal way (see page 26) with black grout. Because your tray is black, the grout around the outside edge of the mosaic does not show up.

tools and materials
Small plate and one slightly larger plate
Metal bowl, 290 mm (11$\frac{1}{2}$ in) diameter
Non-permanent pen
Craft tweezers
Silicone glue
Bradawl or similar tool
Black grout

mosaic pieces
Green beach glass: pieces in assorted sizes
Millefiori: 2 or 3 large, 15 small
Sicis Waterglass tiles: 100 white opaque and transparent,
 130 green
Vitreous glass tiles: 35–40 pink; 300 (approx one sheet) white,
 for outside of bowl
Old pottery/china: a few pink pieces
Sicis glass tiles: 100 white opaque, for outside of bowl

Comb any beach and along the edge of the surf you'll find beautiful pieces of coloured glass worn down by the pounding waves. To re-create the luminous shine of the glass when it is wet, combine it with water and floating candles in this beautiful mosaic bowl. It's not possible to break beach glass without destroying its appealing organic shape, so you need a good selection of sizes.

beach glass
candle bowl

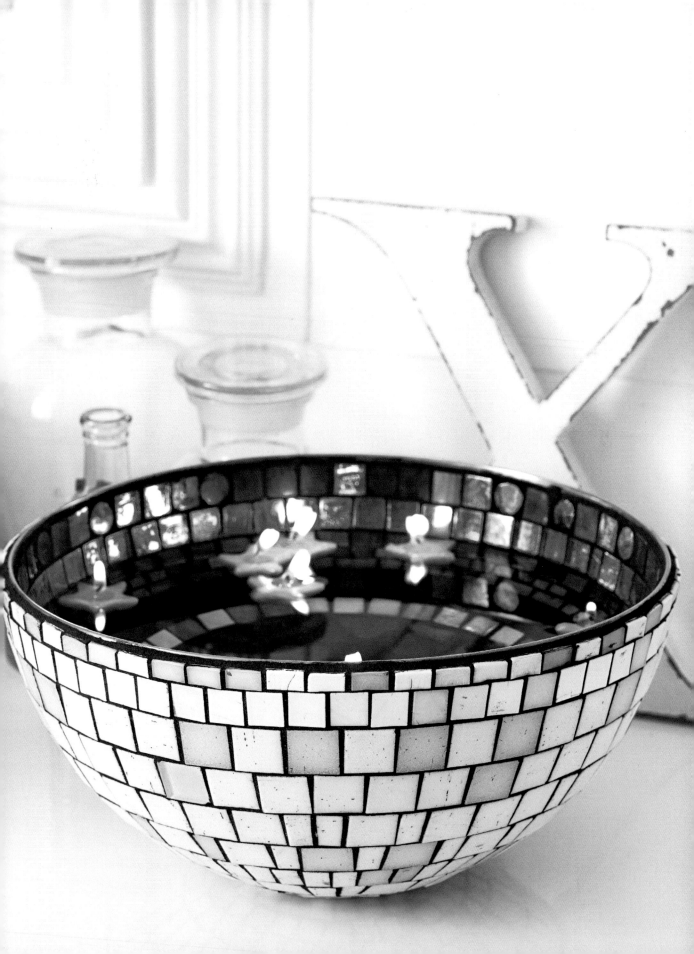

1 Find a small plate to sit inside the bowl at an appropriate level for the amount of beach glass collected. Draw around the plate with a non-permanent pen to give you a guide to work to.

2 Working with one piece at a time and using tweezers, apply silicone glue (see page 25) to the back of the pieces of beach glass and stick them in the base of the bowl. If there are any large gaps, consider dropping in the odd large millefiori.

3 When the base of the bowl has been covered up to the guideline, stick just above it one row of whole Sicis Waterglass tiles in both white opaque and transparent shades, alternated with a few green Waterglass tiles.

4 Next, place another row of beach glass. Again depending on the quantity available, use a slightly larger plate to help draw another guideline for the upper edge of the beach glass area.

5 Now start from the top edge of the bowl and work downwards, laying three rows of whole Sicis tiles. Because the tiles are whole it is easy to stay straight. Do the first two rows in green with the odd tile shaped into a circle (see page 15) in the first row. Use transparent tiles for the third row. Depending on the depth of your bowl there may now be a space left between these rows and the beach glass. Fill the space with one or two rows of vitreous glass tiles in shades of pink, cut mostly into quarters and some halves. Introduce odd pieces of pottery – perhaps another find from the beach.

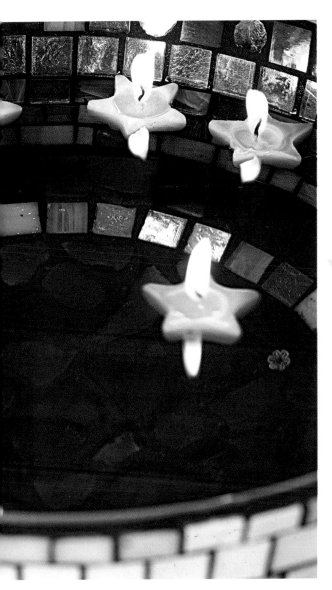

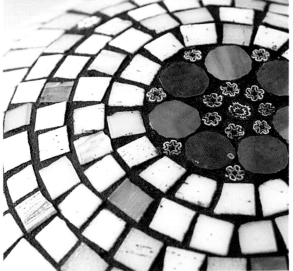

6 The outside of this bowl will not look very pretty left exposed, so is covered by white tiles laid in rows. Stick halved white Sicis tiles along the top edge. Follow with one row of whole Sicis tiles, then several rows of whole white vitreous glass tiles. As you start working towards the base of the bowl turn the bowl over – but not until the inside adhesive is stable so the tiles do not start to slip. You will now need to start using half-tiles and shaping them slightly into wedges to accommodate the curve of the bowl. The last few rows use quarter-tiles, which need to be shaped as described on page 16. Finish off by laying millefiori and circles in a pattern on the base of the bowl. It will never be seen but is a good way of achieving a neat finish, as long as the millefiori allow the bowl to sit flat.

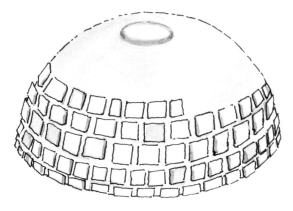

7 Wait at least 24 hours (or according to manufacturer's instructions) for the adhesive to cure before grouting. It is also worth spending some time picking out the excess adhesive from between tiles with a bradawl. Grout (see page 26) the bowl using black grout for the most dramatic effect, the black contrasts with the bright silver metal glinting from behind the transparent tiles. Make sure the two top edges are very neat as they are so visible. Do not fill the bowl with water until the grout has completely cured or the grout will stain.

beach glass candle bowl **49**

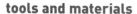

tools and materials

Wooden cube tealight holder, 750 mm (29 1/2 in) cubed
Diluted PVA and paintbrush
White tile adhesive
Disposable piping bag or adhesive spreader
Craft tweezers
Bradawl or similar tool
White grout
Tealight

mosaic pieces per cube

Vitreous glass tiles: 80 white, most cut into quarters
Sicis glass tiles and stained glass: offcuts in shades of white,
 cut into 10 mm (3/8 in) squares
Millefiori: 20 white

Mosaics and candlelight are perfect partners – the reflective tiles used here gleam and glisten in the half-light. This starter project is simple enough for children to do with a little assistance and makes a lovely gift. Inexpensive wooden cubes are available from craft shops, or make your own with a piece of timber and a 40 mm (1½ in) flat wood drill bit. Vitreous glass is available in 10 mm (⅜ in) square tiles especially for children.

tealight cube

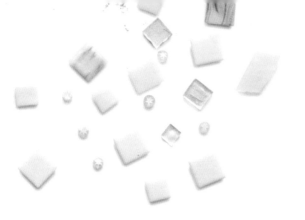

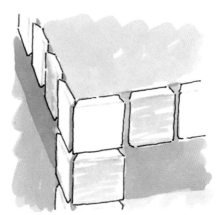

3 Ensure the bevelled tiles almost meet at the corners – it takes a bit of adjusting to get this to happen.

1 Gather together a selection of white vitreous glass tiles, Sicis tiles and stained glass (see page 10) in shades of white to make an attractive and interesting mix. Prepare a supply of quarter-tile sizes but don't cut up all your tiles in advance as you may need some irregular sizes, slightly smaller or larger than normal, to make the pattern fit. Vitreous glass tiles are ideal for this project because they have a bevelled edge. Bevelled edges allow the tiles to sit together closely on the outside edges of the cube and means the bottom edge of the cube will be smooth and won't scratch the surface it stands on.

2 Applying the adhesive (white to match the grout) using a disposable piping bag or adhesive spreader, start by placing bevelled quarter-tiles along all the outside edges of the four side faces of the cube. The bevel should protrude over every edge except around the bottom of the cube.

4 Still using bevelled quarter-tiles, complete the four edges around the top face. Again you'll need to do a little adjusting to get the first tile in each corner to sit comfortably with the ones on the side.

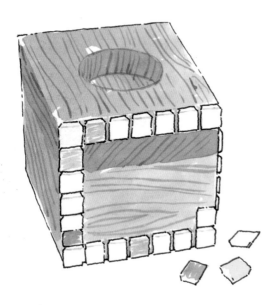

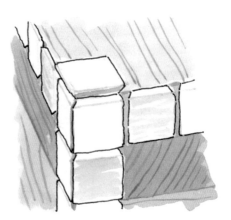

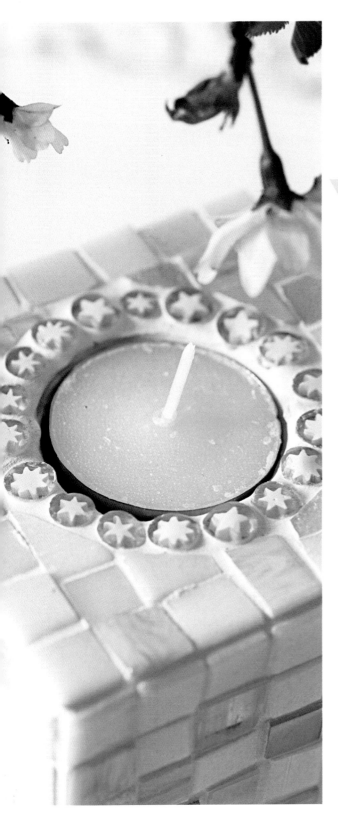

5 Fill in the rest of the side faces, using a variety of tiles, following a neat pattern. Use 'large quarters' or millefiore if necessary to make tiles fit. Take care not to dislodge tiles whenever you turn the cube on to faces that have just been stuck.

6 Using tweezers, stick a row of millefiori around the edge of the hole for the tealight. The tealight is a snug fit so take care not to encroach over the edge or the candle won't fit. Set the beads back a little, remembering to leave some room for the grout. Lastly, cut the tiles to fill in the top of the cube (children may need some help with these more awkward shapes).

7 Before the adhesive hardens, use a bradawl to scratch away any excess adhesive just as it begins to dry out and become crumbly. Leave to dry according to manufacturer's directions. Grout (see page 26) the mosaic cube with white grout and insert your tealight.

tools and materials

Metal table top, 780 x 480 mm (30³/4 x 19 in) (see page 56)

Template on page 119

Pencil and paper

2 pieces of strong polythene, just larger than finished mosaic

Spray adhesive and spray booth (see page 56)

Exterior-grade flexible adhesive (BAL Flex)

Disposable piping bag or adhesive spreader

Piece of fibreglass mesh, the same size as the finished mosaic

PVA glue

Grout float (optional)

Large board and weights

Lighter fluid or 'sticky stuff remover'

Bradawl or similar tool

Water sealant or similar waterproofing/protecting product

Grey grout

mosaic pieces

Loose marble tiles: 100 dark tan, most cut into wedges, for fish body, face outline and tail; 50 dark green/black, for fish outline and tail; 30 light tan, cut into circles, for fish body and tail; 150 white/cream, some cut into circles, for fish body and tail

Gold leaf smalti: 5–6 pieces, 20 mm (³/4 in) square, for the border; 2 pieces, 20 mm (³/4 in) square, for the fish eyes

Mexican smalti: 20 light tan/cream, for fish face; 3–4 black iridescent, for fish eyes

Sheets of marble tiles: 4 beige for background

Marble is irresistibly smooth but hard to cut (see page 10). The dark marble used to outline the fish was cut from marble rods, an easier option than shaping pieces from machine-cut cubes. Even so, some shapes were too challenging and gold leaf smalti was used, green face upwards. The tesserae have different heights so the indirect mosaic method (see page 20) is employed to ensure a flat table surface.

marble fish
table top

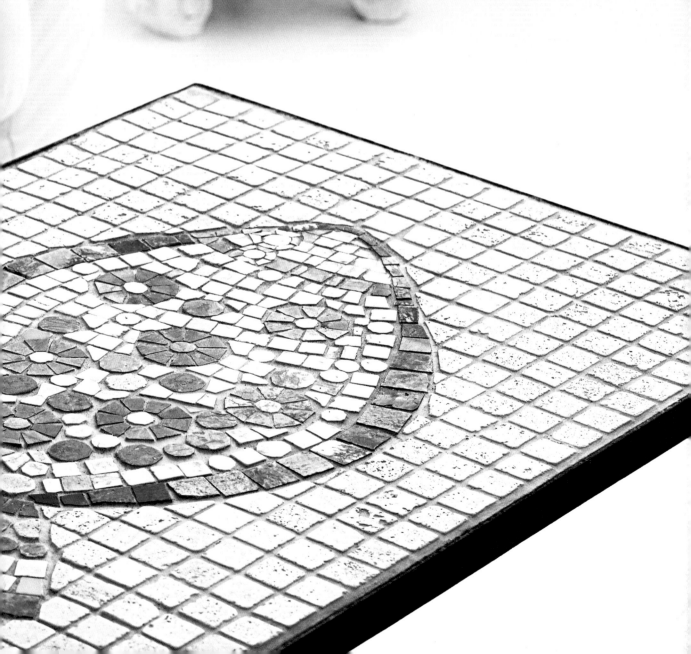

The table top needs sides deep enough to accommodate the depth of the tiles as well as the adhesive. This table was made by a blacksmith, its dimensions in multiples of the whole marble mosaic tiles used for the background. Because of its size and the weight of the material, this mosaic is made on strong polythene and the tiles stuck face down using spray adhesive in a spray booth (see page 22).

1 Using the template as a guide draw your design to size and place it on a work surface. Consider the size and position of your fish in relation to the background, and work out where the fish will sit within the grid of tiles (see Jellyfish Wall Tile Insert, page 94 for guidance). Cover the drawing with a sheet of strong polythene.

2 Lay the wedge-shaped, dark tan-coloured circle features of the fish first, sticking the pieces, best-face down, using spray adhesive. Next mosaic the outline of the fish using pieces of dark green/black marble and 5–6 whole gold leaf smalti, green face down.

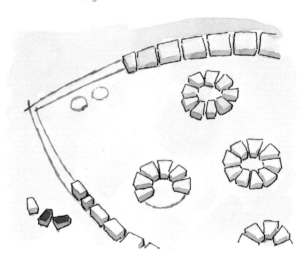

3 Fill in the body of the fish using light tan circles and white pieces cut into 'squares' and circles. Construct the tail as shown in the photograph, then finish by laying light tan/cream Mexican smalti for the face, and black iridescent pieces around gold-leaf circles for the eyes.

4 Once the fish is complete, start laying the parts of whole sheets of the tiles for the background, working from the four outside edges of the design in towards the fish. Cut the tiles that butt up to the edge of the fish as necessary (see page 18).

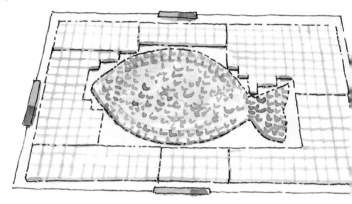

5 With the mosaic complete, the difference in heights of the various materials becomes apparent. To even out the different heights, fill the recessed areas with flexible adhesive using a disposable piping bag or adhesive spreader.

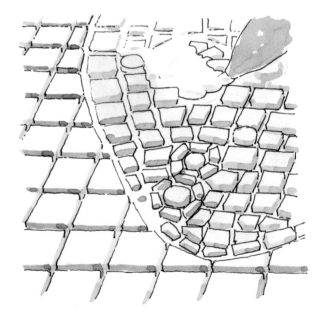

6 When the back of the mosaic is even, place a sheet of mesh over the top, then smooth a layer of adhesive to secure the mesh to the back of the tiles. Dot a little PVA here and there as well and apply it around the edges of the mesh to make them really secure. Place the other sheet of polythene over the back of the mosaic and smooth flat with your hands or a flat object like a grout float.

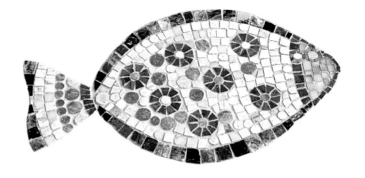

7 Place a board on top, add some weights and leave overnight. This will make the mosaic flat on the back as well as the front and turning it over in one piece will be easy as the mesh will hold it together.

8 Remove the weights and board and gently peel away the polythene. When the adhesive is dry, carefully turn the mosaic over and peel away the original sheet of polythene. Examine the front face of the mosaic before it is set into the table top as this is a good opportunity for minor adjustments. Clean the front of the tiles, sticky from the spray adhesive, using lighter fluid or 'sticky stuff remover'. Pick out any adhesive that has come through to the front of the tiles. It can be a good idea to seal marble with a water sealant or similar waterproofing/protecting product before grouting.

9 Set the mosaic into the table top and grout using grey grout, following Steps 9 and 10 of the Al Fresco Table (see page 41).

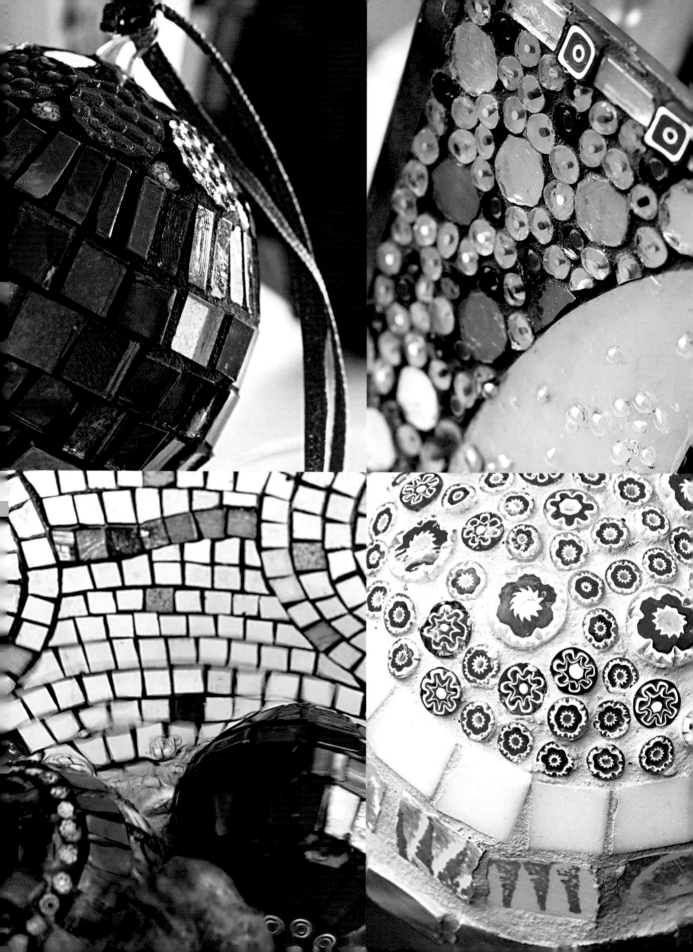

decorative touches

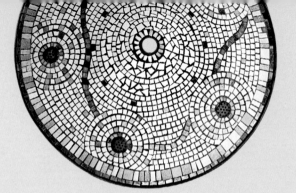

tools and materials

Black marker pen

Metal lampshade or large shallow bowl, 500 mm (19^{1}/$_{2}$ in) diameter, with a hole in the centre

Exterior-grade flexible adhesive (BAL Flex)

Disposable piping bag

Black grout

Large metal plant pot

Water pump

Smaller pots and paving slabs to prop up the water pump

Mosaiced polystyrene balls (see Flower Balls, page 84)

mosaic pieces

Sicis glass tiles: 80 cream and bronze, for rim and around the apertures/millefiori clusters

Unglazed ceramic tiles: 60 in two shades of stone; 400 white/stone plus 50 more in another pale shade

Millefiori: 100 medium (4 mm/5/$_{32}$ in), for centres of circles

Gold leaf smalti, 10 mm (3/$_{8}$ in) square: 6

Antique or gold mirror pieces, 10 mm (3/$_{8}$ in) square: 10

Gold-veined vitreous glass tiles: 30, most cut into quarters, for meandering line

Discovering that mosaiced polystyrene balls (see Flower Balls, page 84) would float was the inspiration for conceiving this miniature fountain to feature them. The base is a discarded metal coolie-style lampshade – it happened to have apertures, which became part of the mosaic design. Any shallow bowl or similar lampshade would do as long as it has a hole in the base for the fountain.

garden bubble
fountain

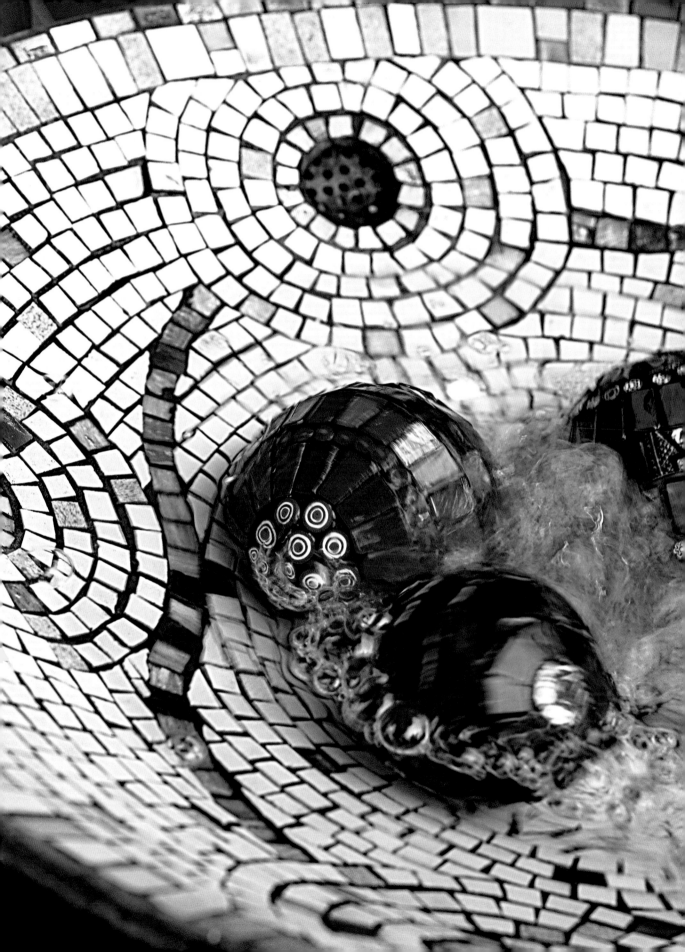

1 Referring to the photographs for guidance, use a black marker pen to draw a similar design on your lampshade/bowl, incorporating five circles spaced around it, linked by a meandering line.

2 Start by sticking tesserae in two circular rows around the outer edge of the lampshade/bowl, applying exterior-grade flexible adhesive via a disposable piping bag. For the first, outer row, lay halves of cream and bronze Sicis tiles end to end. For the second row, lay stone-coloured unglazed ceramic half-tiles at right angles to those in row one, interspersing the half-tiles with the occasional whole tile or two quarters. Use mainly one shade of unglazed ceramic, but add the occasional piece in the other similar shade, at random.

3 Now mosaic the five circles, working outwards from the middle of each. Instead of the little holes already in this lampshade and incorporated within the design, use a cluster of millefiori in the centre of each. Follow this by a circular row of Sicis quarter-tiles, then lay four rows of white/stone unglazed ceramic quarter-tiles and sprinkle some gold tiles here and there to add some intriguing shine. You will need to nibble the quarter-tiles into trapezium shapes to achieve the mosaic circles (see page 16). The circles will not be complete after the first few rows as they will run into the main border.

4 Link the five mosaic circles with a meandering line made from shiny gold-veined vitreous glass quarter-tiles.

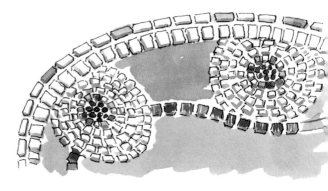

5 Now lay the background using white/stone quarter-tiles and working downwards from the outer edge in neat rows until almost three-quarters of the way down the lampshade/bowl. Space some gold tiles at regular intervals around this row, then break off from the pattern of neat circular rows and start spiralling in a line right to the hole in the middle of the lampshade/bowl. Lay a row of Sicis half-tiles around the hole. Fill in the areas left by the spiral with 'opus palladianum' (crazy paving), using irregularly shaped pieces of unglazed ceramic.

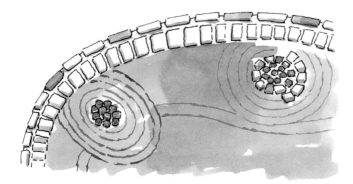

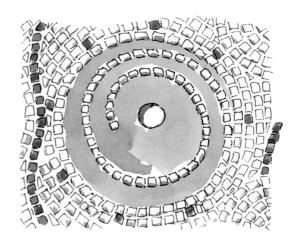

6 Grout (see page 26) the mosaic using black grout.

7 Suspend the finished 'bowl' over a large metal plant pot containing a water pump propped up inside on top of an upturned flower pot and some old paving slabs. Add some mosaiced polystyrene balls and water and switch the fountain on. The burbling water sets the balls continuously spinning about and sending coloured prisms of light bouncing off surrounding surfaces. When you mosaic polystyrene balls make sure you balance them evenly as placing heavier tesserae in any position will weight the ball to one side and prevent it from spinning around in the water.

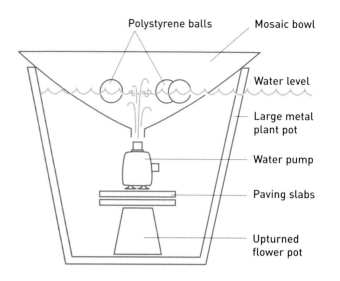

Polystyrene balls
Mosaic bowl
Water level
Large metal plant pot
Water pump
Paving slabs
Upturned flower pot

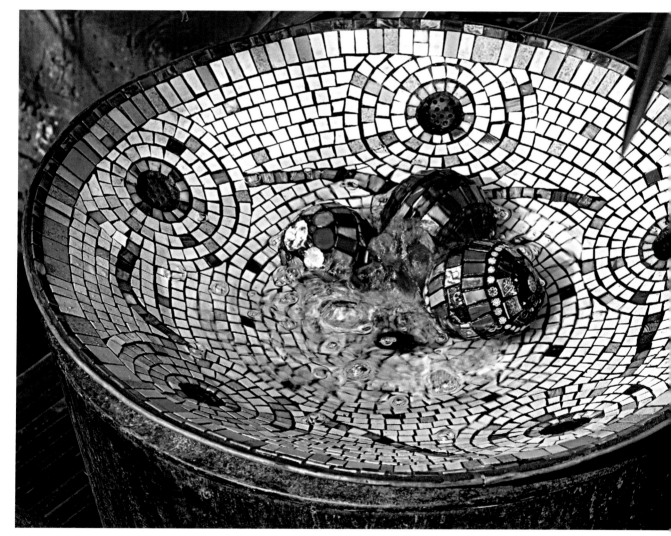

tools and materials

Glass or plastic baubles, 70 mm (2³/₄ in) and 100 mm (4 in)
 diameter
Cup or glass in 2 sizes
Non-permanent pen
Silicone glue
Craft tweezers
Bradawl or similar tool
Black grout
Length of ribbon

mosaic pieces per 90 mm (3¹/₂ in) bauble

Smalti: 10 gold, 12–15 translucent
Mirror tiles: selection of antique gold and plain gold/red, cut
 into pieces
Stained glass: offcuts of textured and plain red/gold, cut into
 pieces
Sicis glass tiles: 40–60 assorted translucent or iridescent in
 gold or reds
Millefiori: 20–50 transparent and opaque

Mosaic inexpensive glass baubles or transparent plastic balls, both widely available from craft shops, with reflective, translucent and iridescent tiles to make these luxurious Christmas baubles. Mix gleaming bright red glass with sophisticated golds and shiny mirror. Hang them near fairy lights and enjoy the stunning reflections.

christmas baubles

1 The place to start mosaicing balls is the circumference, but since there are no convenient guide lines on clear baubles (as there are with polystyrene balls, see page 86), you first need to draw your own. Place each bauble to be mosaiced in a cup or glass that comes close to its circumference. Using the edge of the cup as a guide, draw a line around the middle of the bauble with a non-permanent pen. This will help you lay the first line.

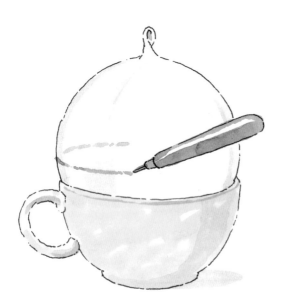

3 Place the bauble in a smaller cup or glass so that the black line around the middle of the ball is clearly visible. Lay a line of silicone glue and stick the first tiles in place (you may be able to use whole tiles here) around the circumference using tweezers. Set the tiles firmly into the adhesive or grout may later seep behind the tile and be visible. Also ensure the adhesive does not rise up between the tiles.

2 It is best to work out your pattern in advance and cut as many tiles/pieces of glass as needed. It would be expensive to cover a whole bauble with gold smalti, so add mirror tiles, stained glass and Sicis tiles in appropriate shades. Also use some transparent smalti.

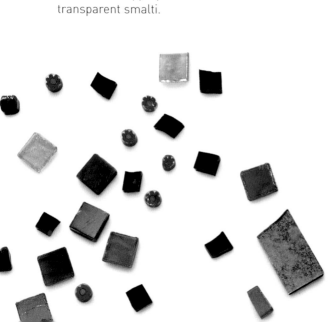

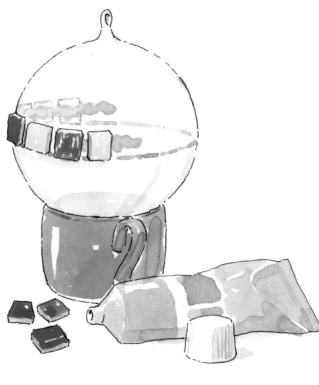

4 Work up to the top of the bauble, laying a variety of tesserae in rows around the bauble. Use quarter-tiles shaped into wedges; use half-tiles, cut at an angle and laid with their wider base nearer the circumference; use circles cut from Sicis tiles and use millefiori.

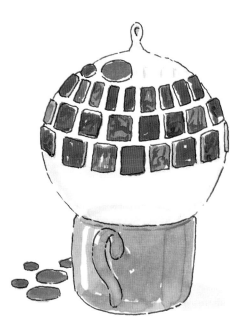

5 Leave the glue to dry completely (you could use this waiting time to start another bauble) before turning the ball upside down to work on the other half. Remove the non-permanent pen line then lay tiles in the same way, finishing off with a group of millefiori, or a tile cut into a circle.

6 Leave for 24 hours until the adhesive has cured. Spend some time picking out any excess adhesive from between the tiles using a bradawl before grouting (see page 26) with black grout. Attach a length of ribbon and display. Hang with care as the bauble is much heavier than the glass loop was designed to support.

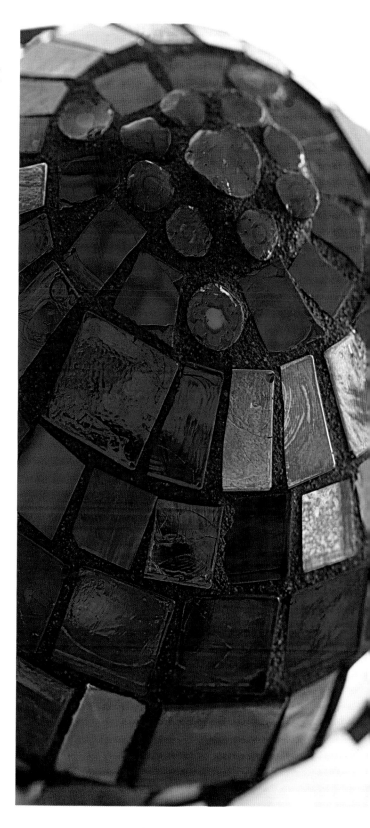

tools and materials

Terracotta birdhouse ball, 180 mm (7 in) diameter
 (see page 128)
Diluted PVA and paintbrush
Pencil
Exterior-grade adhesive, stained black (see page 25)
Disposable piping bag
Black grout

mosaic pieces

Millefiori: 80–100
'Mini azulejos': 15 orange and 10 turquoise, all cut into circles
 and dipped in diluted PVA to seal the porous reverse
Vitreous glass tiles: 10 shiny rust-coloured, cut into quarters,
 for front aperture; 250 rust, cut into quarters, for
 background
Unglazed ceramic tiles: 30 green, 10 cut into circles, the rest
 into quarters
Sicis Waterglass tiles: 60 orange/red shade, cut into circles

Designed as an alternative nesting space, the spherical shape of this terracotta Birdball™ house reflects that of a real bird's nest. Decorated with mosaic it becomes an intriguing work of art hanging in the garden or from a balcony – a real conversation point with visitors and a contemporary home for all kinds of small garden birds.

birdhouse ball

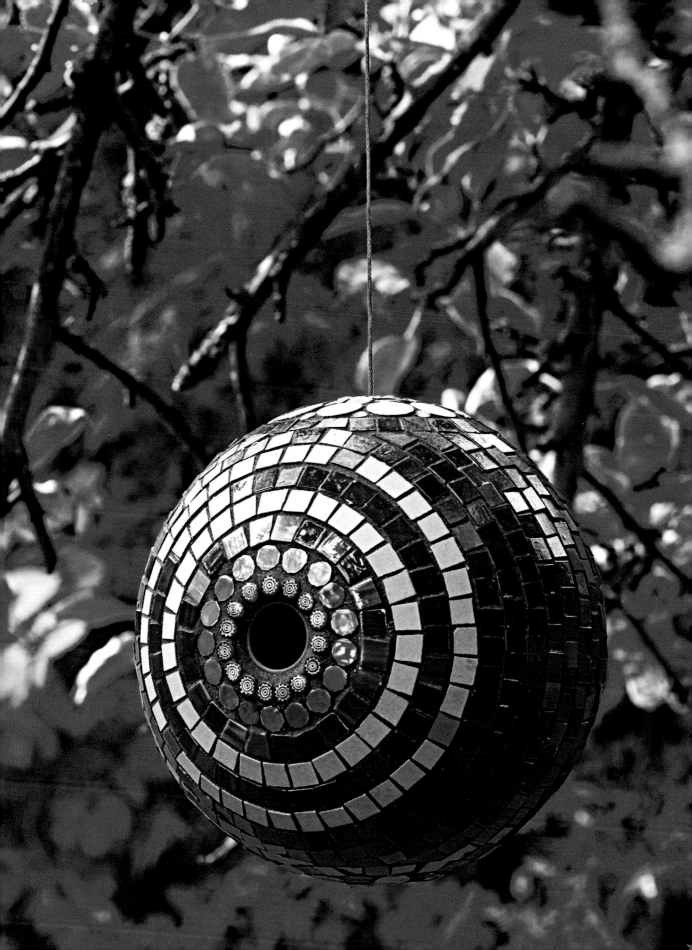

3 Work outwards for another four circular rows, alternating rows of green unglazed ceramic quarter-tiles with rust background quarter-tiles, as shown.

4 Next work outwards from the tiny aperture at the top of the ball to make circle 2. Lay a row of millefiori, then a row of turquoise 'mini azulejos' circles, followed this time by a row of green unglazed ceramic circles. Place one millefiori between each circle, then finish off with a row of the rust background quarter-tiles. If the work 'crashes' into the front circle trim your tiles accordingly.

1 Using a pencil, draw a straight line downwards from the centre bottom of the large front aperture, passing over the tiny aperture on the base, right around the back of the ball and up to the aperture on the top. This pencilled guide line will help you place the group of circle designs on the back of the ball.

2 Piping the adhesive where required, stick a row of millefiori around the front aperture, set back a little to allow room for the grout as you must not encroach on the size of this hole. Follow this with a row of orange 'mini azulejos' circles. For the third row use the shiny rust-coloured vitreous glass tiles, cutting a few wedge shapes as necessary to help the curve (see page 16).

5 Leave the work aside until these tiles are secure, making sure you have not left any clumps of adhesive on the ball, as it will dry out and be hard to remove.

6 Turn the ball over, prop it up with cloths and now work around the aperture at the base of the ball (circle 3). Place a row of millefiori around the hole, followed by a row of Sicis circles, then finish with a row of the rust background quarter-tiles.

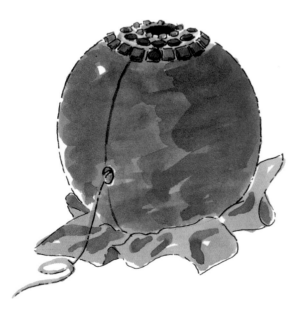

7 Repeat this circle pattern to add four decorative circles on the back of the ball. (Since these have no central hole the centre of these circles is made up only with millefiori.) Having determined the diameter of circle 4 (equal to that of circle 3), place the centre bead on the pencilled guideline at a distance so that the finished outside edge of the circle will touch the outside edge of the next one.

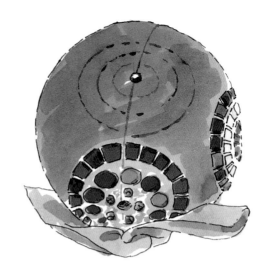

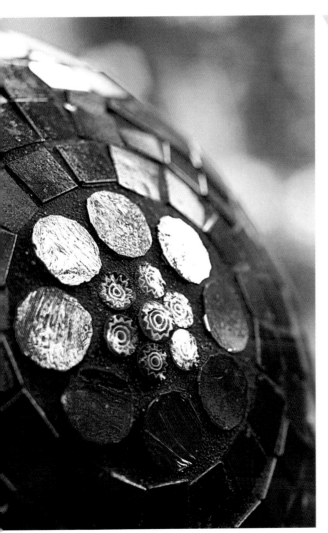

8 Working outwards from the front aperture (circle 1), continue laying the rust background tiles for approximately seven rows, before you encounter the circular patterns on the reverse of the ball. After this, it's just a matter of filling in the rest of the background in a neat and symmetrical way. Perhaps use a few single Sicis circles to fill awkward gaps. Note that the design will vary according to how tightly the tiles are laid.

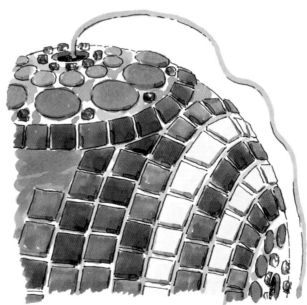

9 When it is dry, grout (see page 26). The finished ball is quite heavy but the fixings are strong, so it should not be a problem.

birdhouse ball **71**

tools and materials

Glass lamp, 100 mm (4 in) square base, 230 mm (9 in) tall
Dinner plate, for use as a template
Chinagraph pencil or felt-tip pen
Oil-filled glass cutter
Running pliers
Silicone glue
Craft tweezers
Bradawl or similar tool
Black grout

mosaic pieces

Stained glass sheets: 2 textured designs (one iridescent, one
 knobbly clear glass), for large curved pieces
Coloured glass sheets or offcuts: green and red
Sicis Waterglass and Glimmer tiles: 160 in various brightly
 coloured and clear shades
Millefiori: 16 square in coordinating colours, for top edge;
 250 transparent round, in several designs, for two spotty
 faces of the lamp; 40 small square, for two stripy faces

Mosaic an inexpensive plain glass lamp, readily available from large homeware stores, with gorgeous textured stained glass and Sicis glass tiles. Combine gentle curves and jovial spots with a geometric design of squares and rectangles. Grout the pieces in black to give your lamp the appearance of a small stained glass window, which casts beautiful colours on to surrounding walls.

stained glass lamp

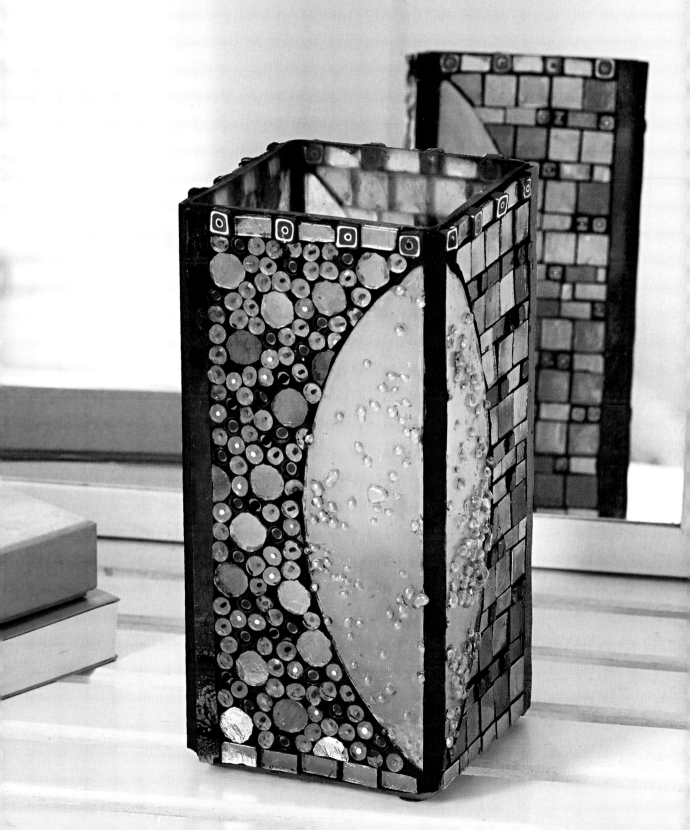

1 Lay the lamp on its side and lay a dinner plate over one face so that the edge of the plate 'bites' into the rectangle. Mark the plate at the edges using a chinagraph pencil or felt-tip pen.

2 Lay the marked plate on a piece of stained glass, aligning the marks on the plate with the edge of the piece of glass. The piece should be wider than the plate by 20 mm (3/4 in) on each side so that you are not cutting the glass to a sharp point. Score the curved line, using the edge of the plate to guide the oil-filled glass cutter.

3 Use the running pliers to grip the edge of the glass at one end and squeeze gently. There may be a slight movement, then squeeze from the other end. Repeat, and this time it should break in a curve. Cut all four pieces of stained glass in the same way. Stick a piece firmly on each face of the lamp, referring to the template as a guide, using a generous amount of silicone glue. Squeeze as many air bubbles out as possible and make sure all the edges are sealed to prevent grout creeping under the glass later.

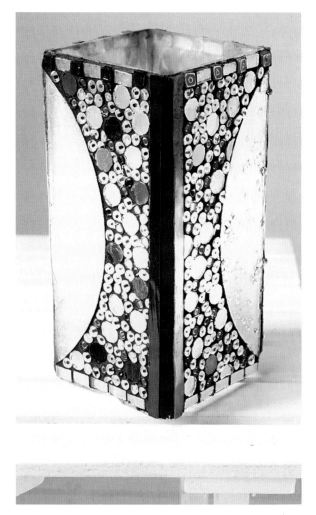

4 Cut four strips of coloured glass, 10 mm (3/8 in) wide, from a sheet and stick one on each face of the lamp, on the opposite edge to the curve. Using tweezers to place tesserae in position, make the border for the top of the lamp by interspersing three Sicis half-tiles with four large square millefiori on each face. Stick a row of clear Sicis half-tiles all around the bottom of the lamp.

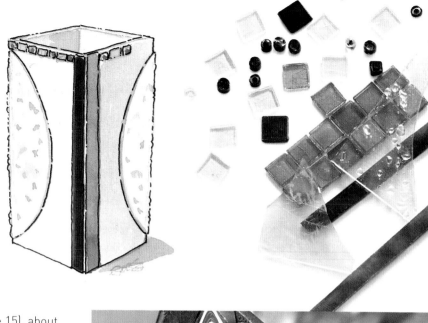

5 Cut a number of circles (see page 15), about 40, from brightly coloured and clear Sicis tiles. Using two different colourways, stick these on to two faces of the lamp together with the transparent round millefiori. On the other two faces lay rows of Sicis whole tiles and half-tiles interspersed with small square millefiori. Shape tiles accurately, by laying them over the gap left to fill and marking with a non-permanent pen before nibbling into shape (see page 18). Leave to dry.

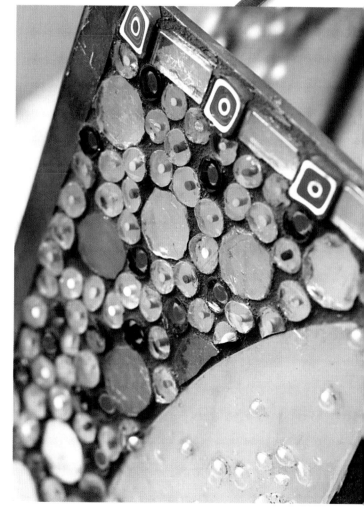

6 Before grouting pick out any excess silicone glue using a bradawl, then mask off any textured glass that may become ingrained with grout. Grout (see page 26) the whole lamp using black grout. The four vertical edges take quite a bit of grout so do these areas in two separate grouting sessions.

stained glass lamp **75**

tools and materials

4 large deep plastic trays, 400 mm (16 in) diameter and
 50 mm (2 in) deep: 3 for use as moulds, 1 for use as a
 practice tray
Polythene
Petroleum jelly
Cement
Builder's sand
Aggregate
Old bucket or bowl and wooden spoon
Water sprayer
Liquid plasticizer
Old metal spoon, for removing mortar from between pebbles
Flat object, for example a piece of wood, for tamping
Beach glass (optional)
Old sieve
Large paintbrush

mosaic pieces

Assorted pebbles

Create beautiful art to walk on using sand, cement and stone. Everyone loves collecting pebbles – their appeal comes from their organic smoothness, interesting colours and variety of shapes. However, it is not possible (or legal) to take vast quantities of pebbles from beaches or river beds, so you may need to look at specialist suppliers. Garden centres are a good source of plastic trays for use as moulds.

pebble
stepping stones

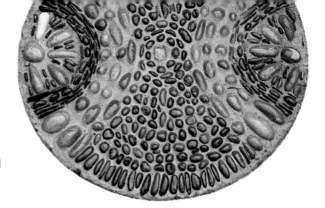

1 Line the bases of three plastic trays with polythene and smear the sides with petroleum jelly so that your stepping stone may be easily eased out later. Stones that are to be walked on need a base layer of concrete – a mix of cement, sand and aggregate (all available from any builder's merchant) in the ratio 1:2:3. Mix these together thoroughly in an old bucket or bowl and add water slowly until the mixture sticks together when you grab a fistful of it. Level about 2.5 cm (1 in) into the base of the trays and rough the surface. Leave for at least 2 hours. (If you will need to move these bases before they are stable place them on a board, otherwise they will crack when you lift the tray.)

2 Next, sort the pebbles into piles of shapes and also into colours – douse the pebbles with a water sprayer as the colours are much more obvious when wet. In order to make effective patterns, you need plenty of same-sized pebbles, for example round, egg-shaped, elliptical, flat.

3 Fill a fourth tray with sand for practising your designs. Press the pebbles into the sand so they won't fall over. Sit the pebbles very close together – it's always surprising how many are needed. Set the practice tray next to the first tray, so you can remove the stones from the practice tray and set them straight into the mortar.

4 When you are happy with your design, make mortar for the first stepping stone. Mortar is a mix of cement and sand in the ratio 1:5. Mix the dry ingredients together, add a little liquid plasticizer (or according to manufacturer's instructions) to extend the working time, then slowly add water, again until the mixture sticks together when you grab a fistful.

5 Spray the base layer with water if it has dried out and add the mortar, making sure it is a little deeper than the largest pebble in the design. Scratch the design on the surface and start your mosaic immediately – you have about 2 hours before the mix goes off, less if you are using a small amount. Wet the stones before pushing them into the mortar, burying about half of each pebble. Carefully remove any excess displaced mortar using the end of an old spoon, disturbing the surface as little as possible.

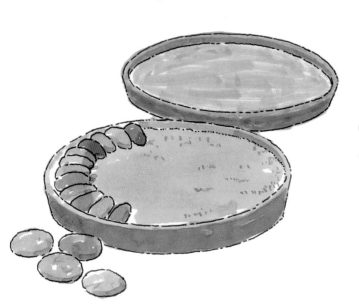

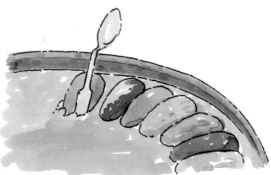

6 If you are going to walk on the mosaic make sure the final surface is reasonably level, pack the stones tightly together and use a flat object to tamp the pebbles to approximately the same height. If the stepping stones are to be purely decorative you could add extra touches like beach glass or other 'found' items. Wrap in polythene and set aside.

7 When the mortar is just set, after about one day, sprinkle a mixture of sand and cement (ratio 3:1) over the surface using an old sieve, and brush into the gaps to give a very level final surface.

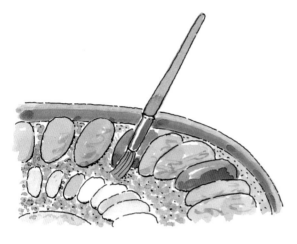

8 Spray thoroughly with water in a very fine mist.

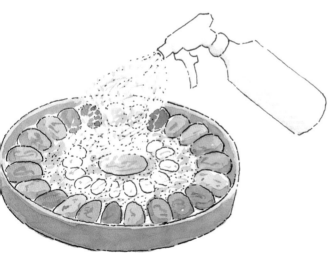

9 Wrap the mosaic and tray in polythene and put it somewhere cool to cure. The slower it sets, the stronger it will be. After a few days remove the mosaic from the tray, wrap it up again and leave for a few weeks before installing.

tools and materials

Small item of furniture, cleaned
Paint and paintbrushes
Sandpaper
Template on pages 122–123
Black marker pen
Paper
Polythene
2 squares of fibreglass mesh, each larger than the finished
 artwork size (see page 82) by 10 mm (3/8 in) all round
PVA glue
Craft tweezers
Grey grout (see page 83)

mosaic pieces

Smalti: 100 orange, 100 green
Millefiori in a range of sizes: 250 mixed green, 250 mixed
 orange, 60 mixed pink
Unglazed ceramic tiles: 120–150 stone-coloured
Vitreous glass tiles: 25 green, 25 pink, 1 orange

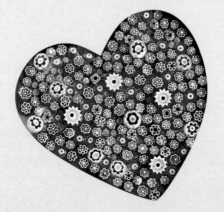

Look for an old piece of furniture in need of a makeover. This 1950s laundry box is the perfect blank canvas for a mosaic extravaganza – pink hearts and masses of flowery millefiori in vibrant colours. Working on even small items of furniture is not always practical so the mosaic is made on a mesh and stuck on to the furniture later. This design is unsuitable if you have very small children as the millefiori are not grouted and could detach.

zingy
laundry box

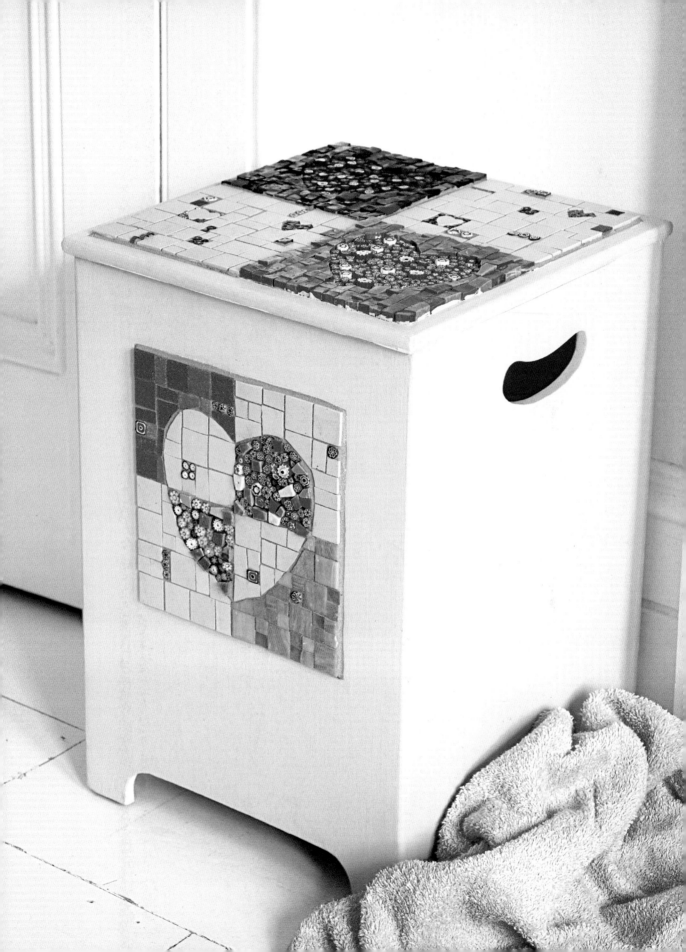

Smalti is often left ungrouted because grout dulls the colours and sticks in the uneven surfaces. Both the smalti and millefiori are ungrouted here, although you can grout them if you prefer. An alternative is to use Mexican smalti, which has an even surface and the colour, although less intense, is not dulled by grouting. Note that the edges of smalti can be sharp, so smooth any exposed corners with sandpaper.

1 Paint your chosen piece of furniture if you like but ensure the areas to be covered with the mosaic mesh are bare of paint and varnish. Sand these areas if necessary to roughen the surface and provide a 'key' for the adhesive.

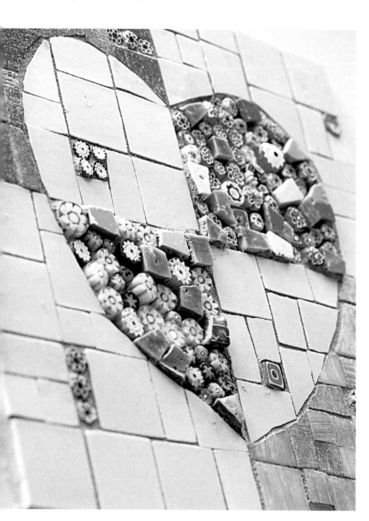

2 Using the template, draw the designs to the required size on two pieces of paper. (The artwork in this project measure 290 mm (11$\frac{1}{2}$ in) square for the top and 185 mm (7$\frac{1}{4}$ in) square for the front of the box.) Cover each with polythene and mesh (see page 19).

3 Start with the design for the top of the box, laying the green smalti heart first. Plan the work so that you need cut the smalti at the sides of the heart into halves only rather than incredibly fine slivers, which is difficult. Also plan for two bricks to meet exactly in the middle at the top and bottom of the heart.

4 Using PVA to stick the pieces, start with an outside edge and work across the design in rows. Choose smalti bricks of a similar height to the one laid next to it and start every other line with a half brick to achieve a staggered brick pattern. Pack the bricks really closely together.

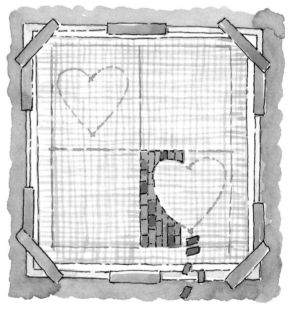

5 Make the orange smalti heart in the same way then infill both with millefiori using tweezers. Use plenty of PVA as this area will not be grouted.

6 Now complete the two patchwork square designs, using pieces of ceramic tiles, interspersed with the occasional heart feature, orange vitreous glass quarter-tile and millefiori. Nip tiles to fit gaps by holding the tile over the work.

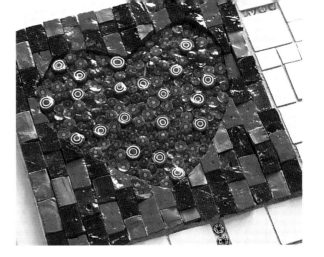

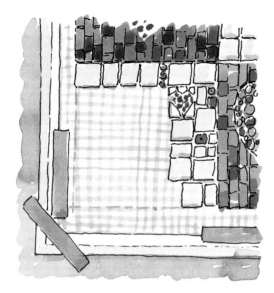

7 Set aside to dry. When the PVA is stable turn the work over to complete the drying and trimming process described on page 20.

8 Now mosaic the mesh for the front of the box. Use some irregular smalti pieces with the millefiori infill to use up some of those expensive smalti shards. Use pieces of stone-coloured ceramic tiles, and green and pink vitreous glass for the background, as illustrated. When cutting tiles to achieve curved lines, start at the curve rather than leaving the curve to be the last thing you cut.

9 When this piece is also completely dry and trimmed, as per Step 7, install both pieces. Cover the marked out area on the top of the box with PVA. Use enough to stick the mosaic mesh, but not so much that the glue will rise up through the millefiori. Leave to dry. When you can turn the box without the first piece of work slipping, stick the second piece in the same way.

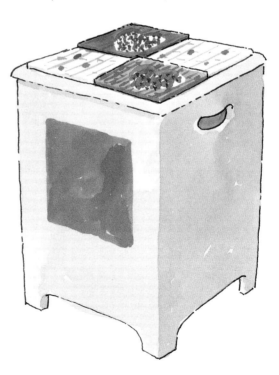

10 Leave to dry and then grout (see page 26) the areas you wish to, masking off the areas you need to keep clean. Touch up the paint on the box if necessary.

zingy laundry box **83**

tools and materials

Several polystyrene balls, 100 mm (4 in) diameter

Diluted PVA and paintbrush

Small cups or jam jars

Exterior-grade adhesive

Disposable piping bag

Craft tweezers

Bradawl or similar tool

Grey and black grout

Old metal implement for making hole in polystyrene
 (see page 87)

Bamboo or metal poles

mosaic pieces per ball

Vitreous glass tiles: 20

Sicis glass tiles: 20

Smalti: 20

Millefiori: 50–200

Selection of mixed china and buttons

Cover polystyrene balls with a selection of tiles and beads for a simple project with limitless options. Mounted on poles, these flower balls make a cheery sight in the garden, particularly out of season when rain sparkles on their bright decorative surface. Use them in a fireplace or bowl as a decorative centrepiece or, since they float, you can even use them in a water feature (see Garden Bubble Fountain, page 60).

flower **balls**

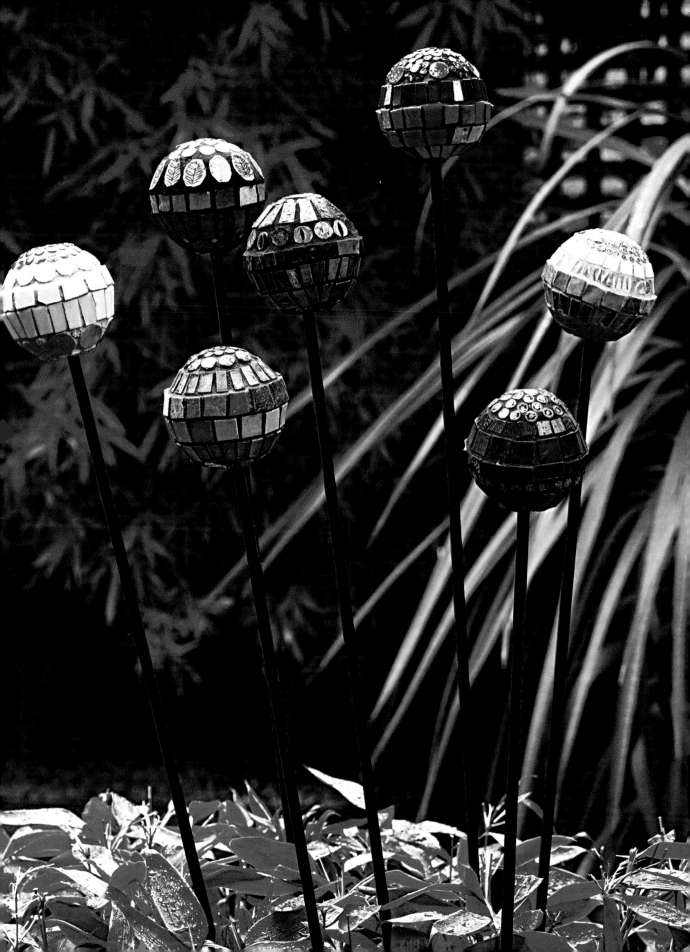

1 Seal the polystyrene balls with diluted PVA. Sit in small cups or jam jars and leave to dry.

2 Mix the adhesive to a stiff consistency. Using a disposable piping bag and following the convenient guide lines provided on polystyrene balls, lay a line of adhesive around the circumference of the ball. Stick the first pieces in place using tweezers. On all but the smaller sized balls, vitreous glass tiles and certainly Sicis tiles can be used whole around the circumference. Smalti also works well for the starting row. (If you choose to use china, remember that the glaze may not withstand extremely cold temperatures.)

3 Work up towards the top of the ball, laying a variety of tesserae in rows around the ball. Use quarter-tiles shaped into wedges; use half-tiles, cut at an angle and laid with their wider base nearer the circumference; use circles cut from Sicis tiles and use millefiori. Remember to keep pushing the adhesive down between the tiles; it is easier to do this, or scrape it away with a bradawl, when it has dried a little and is becoming crumbly.

4 At the top of the ball, it is fun to represent the flowerhead with millefiori, or maybe a pattern using china.

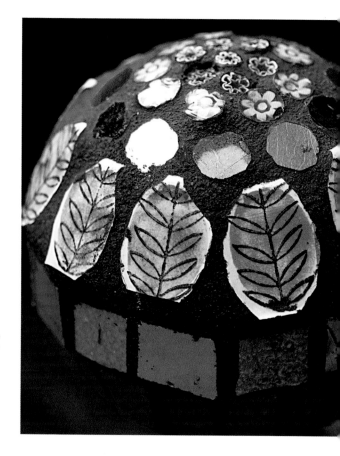

5 Leave the adhesive to dry completely (you could use this waiting time to start another flower ball) then turn the ball upside down and replace it in the cup or jam jar so you can work on the other half. Lay tesserae in the same way, leaving a gap large enough to take your bamboo or metal pole.

6 When all the flowers are finished, leave for 24 hours, then grout (see page 26) using grey grout or another suitable colour. Now mount the balls on to poles. Do not force the pole into the ball as the displaced polystyrene will cause your tiles to pop off. Taking great care, heat a piece of metal, then push it gently two-thirds of the way into the ball. It will very easily melt the polystyrene leaving a neat hole. Make the hole slightly smaller than the pole, so it fits tightly. Whatever implement you use, you will be left with a residue of sticky burnt polystyrene so don't use the family silver!

7 Until the grout is completely cured, don't be tempted to display your mosaic balls outdoors because the grout will stain if exposed to rain.

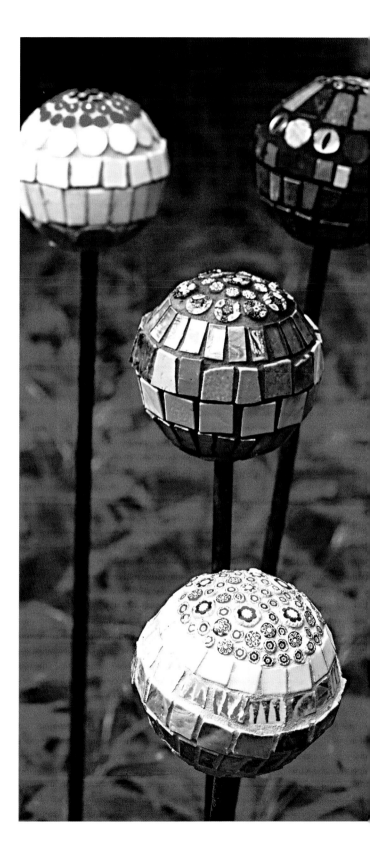

flower balls **87**

wonderful walls

tools and materials

Piece of MDF, 250 mm (10 in) square
Diluted PVA and paintbrush
Template on page 125
Carbon paper
Pencil
2 D-rings, screws and picture wire
Tile adhesive
Disposable piping bag or spreader
Bradawl or similar tool
PVA
Oil-filled glass cutter (optional)
Black grout
Brown paint and paintbrush

mosaic pieces

Old china: selection of pieces including plates, a cup handle
 and china leaves
Vitreous glass tiles: 60–80 mid-brown, most cut into wedges,
 for plate and coffee; 60–80 dark brown and black, cut into
 quarters and halves, for lower background; 10 dark/shiny
 gold/grey/brown, for background;
Mirror glass tiles: a few, for 'bowl' of spoon
Millefiori: 20, for spoon
Smalti: a few thick brown translucent, for spoon handle;
 70 rust-coloured for border edges; 4 red, for border corners
Unglazed ceramic tiles: 60–80 light beige and cream,
 for upper background

Incorporating broken china into your mosaic work allows you to place a unique stamp on a project. This wall plaque will look great in any kitchen or eating area. Be inspired by your existing colour scheme or by old bits of crockery found in charity (thrift) shops. Designs from the 1960s and 1970s often have strong patterns that make for a bold design.

kitchen plaque

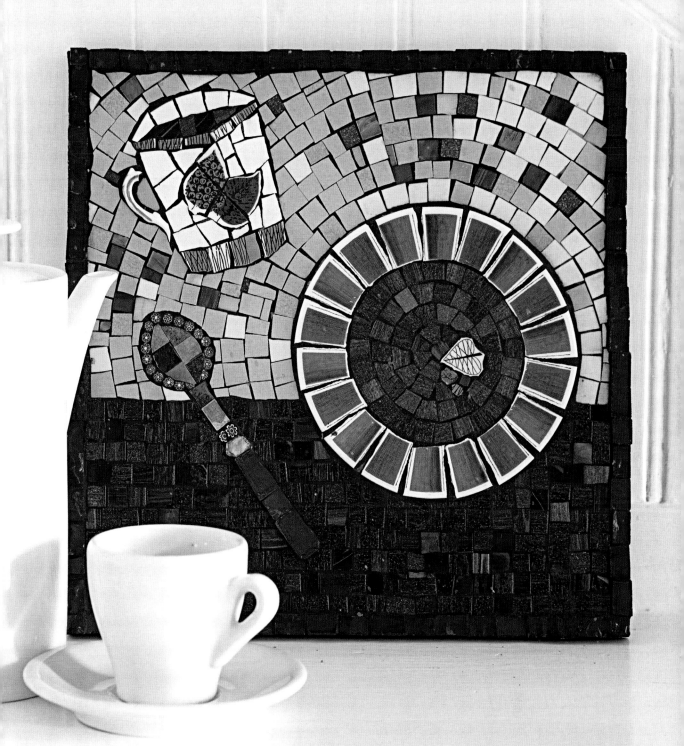

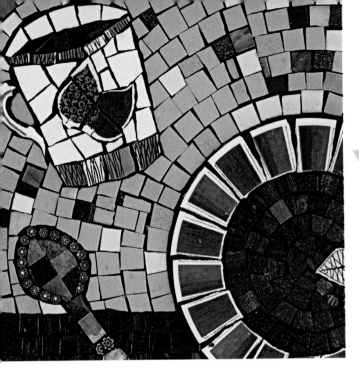

3 When the adhesive begins to dry and becomes crumbly, carefully scrape away any excess from the edges of the plate and around the cup and handle using a bradawl.

4 Using PVA for this step (and the rest of the project), glue a china leaf or something similar in the centre of the plate. Then start laying mid-brown vitreous glass wedge shapes in rings, working around the china leaf in the centre.

1 First, prime all the surfaces of the MDF board with diluted PVA. Using the template and carbon paper, transfer the design on to the MDF board (see page 19). Screw the D-rings to the back of the board, then remove them and set aside.

2 Start by laying the pieces for the plate and cup. Break the china into pieces to provide pieces for the plate rim, the cup and cup handle. Glue the pieces to the board using tile adhesive. This adhesive has some body to 'grab' the uneven pieces and allows you to prop up the pieces for the plate's rim so that it can stand proud of the surrounding tiles. Lay a few mid-brown vitreous glass tiles to represent the coffee in the cup.

5 Next lay the pieces for the spoon. Shape the mirror glass tiles for the 'bowl' of the spoon – ideally using a glass cutter, although you can use tile nippers if you are careful. Glue in place then outline the glass pieces with millefiori and stick down a few thick brown translucent smalti tiles for the spoon handle so this, too, will stand proud of the mosaic background.

6 When the main features have been laid, stick the rust-coloured smalti bricks around the border, placing a red piece in each corner.

7 For the lower, dark, half of the background of the plaque, lay the mosaic pieces in parallel rows across the board. Start working at the curve of the plate so that you control the size of the tesserae at the most prominent part of your work. To avoid using very small pieces, shape pieces from a half- rather than a quarter-tile. The pencilled lines are only a guide – don't be afraid to deviate from them to create more interest.

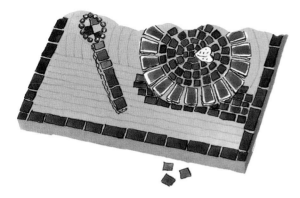

8 Lay the beige/cream tiles for the remaining background by following the curve of the plate. 'Crash through' the cup and spoon, judging how the tiles might fall if the cup and spoon weren't there. Intersperse the base tiles with darker/shiny tiles from time to time, ensuring you distribute them evenly. Where the background meets the smalti border avoid using tiny pieces to fill the gaps.

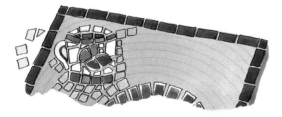

9 Leave to dry for 24 hours, then grout (see page 26) the work with black grout, carefully filling in beneath the rim of the raised plate to give a smooth finish. Paint the edges and the back of the MDF board brown. When dry, replace the D-rings on the back and link with picture wire so your plaque is ready to hang.

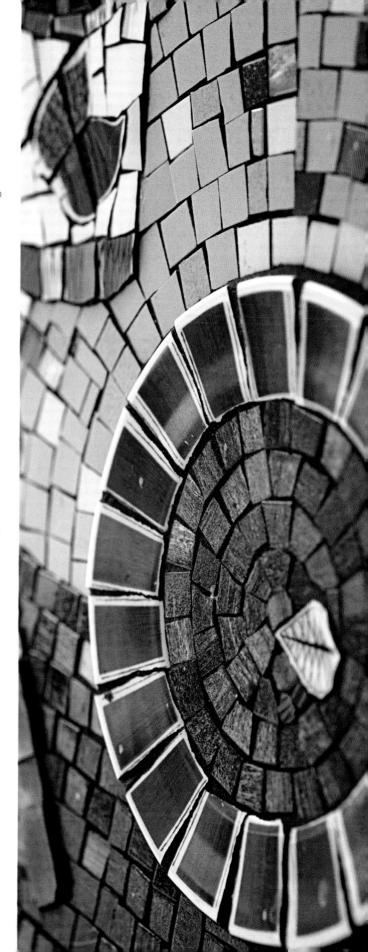

tools and materials

Large sheet of paper
Pencils and ruler
Template on page 124
Black marker pen
Large sheet of polythene
Piece of fibreglass mesh
PVA glue
Craft tweezers
Non-permanent pen
Oil-filled glass cutter and running pliers
Tile adhesive
Notched spreader
Grout float
Pale-coloured grout

mosaic pieces

Glazed ceramic mosaic tiles: sheets of pale-coloured tiles, for background
Stained glass: several sheets in turquoise and purple
Sicis glass tiles: 6–10 pale blue, cut into circles
Millefiori: 230 purple and turquoise, in various sizes

This diaphanous jellyfish with gossamer beady tentacles appears to float on the bathroom wall. Mosaics installed in bathrooms are often made with the indirect method to ensure a flat surface, but because of the bumpy millefiori used here, mesh is used (see page 19). Simply leave an area of your bathroom wall untiled and insert the mosaic artwork into the space before grouting.

jellyfish wall tile
insert

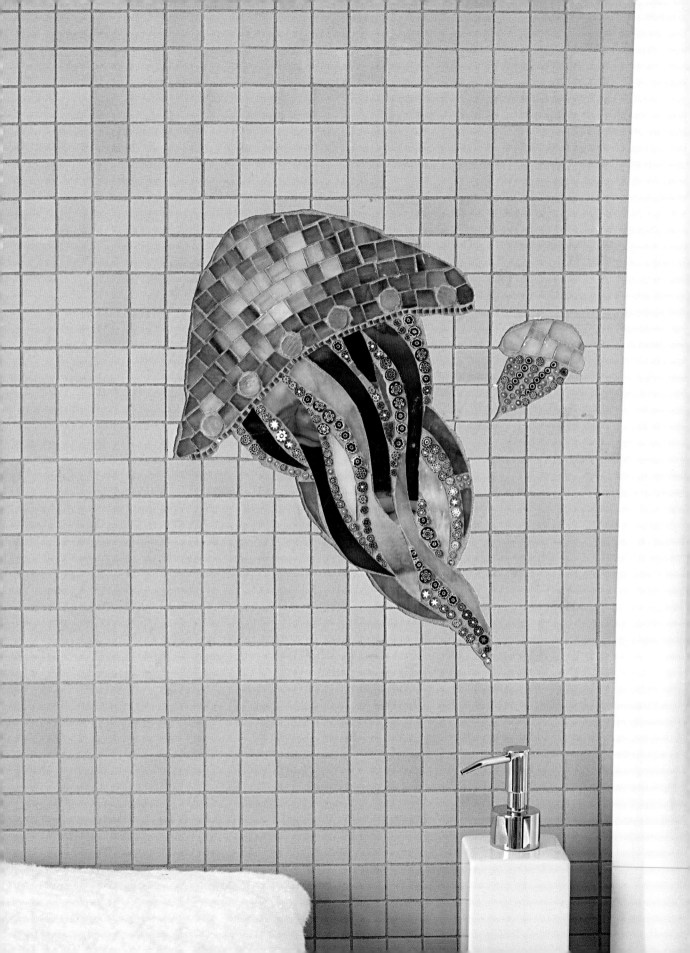

1 Plan the bathroom wall, deciding on the position and size of the jellyfish. Leave a rectangular section on the wall untiled, to receive the finished artwork. The dimensions of this section must be in multiples of the whole tiles used on the wall.

2 Take a whole sheet of the tiles being used in the bathroom and place on top of a large sheet of paper. Make a mark on the paper at each end of the spaces in between the tiles, then join them up with a ruler to make a grid. Extend the grid as necessary to match the size of the untiled section left for the jellyfish insert – 300 x 330 mm (12 x 13 in) in this instance. Using a different coloured pencil and the jellyfish template, draw the jellyfish outline carefully over the grid. Plan where to break the tiles at the edge of the jellyfish, avoiding the need for a tiny piece of tile or a difficult shape.

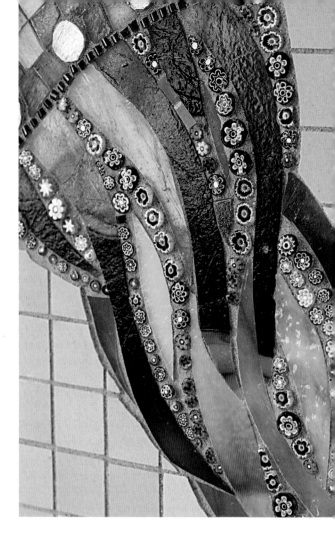

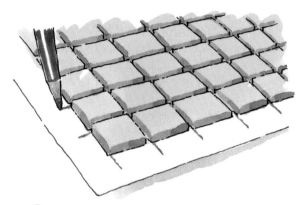

3 Go over the outline in black marker pen. Cover the drawing with polythene and lay the mesh over the top (see page 19).

4 Stained glass has lovely translucent, swirling surface colours, but don't choose areas from the sheet that are transparent or the mesh will show through. Selecting from different areas of the glass to create the appearance of light and shade, cut a good reserve of 10 mm (3/8 in) squares. Using PVA, start sticking tiles to the mesh, working upwards in rows to complete the jellyfish body. For the first row, alternate a Sicis circle with two stained glass squares. Thereafter, use the squares of stained glass, nibbling to shape when required, to fit around the circles.

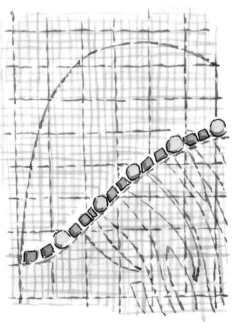

5 To finish the body, lay a line of millefiori beads on their sides with the help of tweezers to separate the body and tentacles.

6 Take several sheets of stained glass and, using a non-permanent pen, draw curves on them to make the jellyfish tentacles. Cut the glass using an oil-filled glass cutter and running pliers (see page 74). Lay the pieces over each other and trim so they fit together in a pleasing 'floating' manner. Stick them in place on the mesh and fill in the gaps with rows of millefiori beads – trim millefiori if necessary to slot them into small spaces.

7 Construct the small jellyfish using tiles of stained glass for its body and rows of millefiori for its tentacles.

8 Fill in the background of the section using sheets of whole mosaic tiles as far as possible. Align them carefully with the grid so that when the mosaic insert is placed on the wall it will be seamless with the existing wall tiles. Cut the tiles that butt up to the jellyfish as necessary (see page 18).

9 When the PVA has dried enough to be stable, carefully turn the work over and peel away the polythene. Leave to complete drying, then trim the excess mesh (see page 20). To install, apply tile adhesive with a notched spreader on to the untiled section of the bathroom wall. Position the artwork on the wall, apply an even pressure using a grout float and remove any excess adhesive that squeezes up through the mesh.

10 When set, grout (see page 26) the whole wall using a pale-coloured grout.

tools and materials

3 mm (1/$_8$ in) mirror glass, 450 x 400 mm (17^3/$_4$ x 16 in), with
 ground edges for safe handling
4 mm (5/$_{32}$ in) mirror glass, 330 x 300 mm (13 x 12 in) (the
 same depth as Sicis tiles when backed with adhesive)
Silicone or polyurethane glue
Non-permanent pen
Bradawl or similar tool
Black grout
Super-strength glue; or MDF, paint, paintbrush, 2 D-rings,
 screws and picture wire

mosaic pieces

Gold mirror (some antique), 15 mm (5/$_8$ in) squares: 80
Sicis glass tiles: 120 clear and iridised clear shades (for
 example Waterglass 'icewater' and Glimmer 'ginger')

Have a glass supplier cut two pieces of mirror to size, then combine gold mirror tiles and Sicis glass tiles to make a gorgeous mosaic frame.
This project is easy to do and requires very little tile cutting.
Using black grout outlines each tile to create a stained glass effect and the occasional antique mirror tile gives the mirror a really classy feel.

glitzy **mirror**

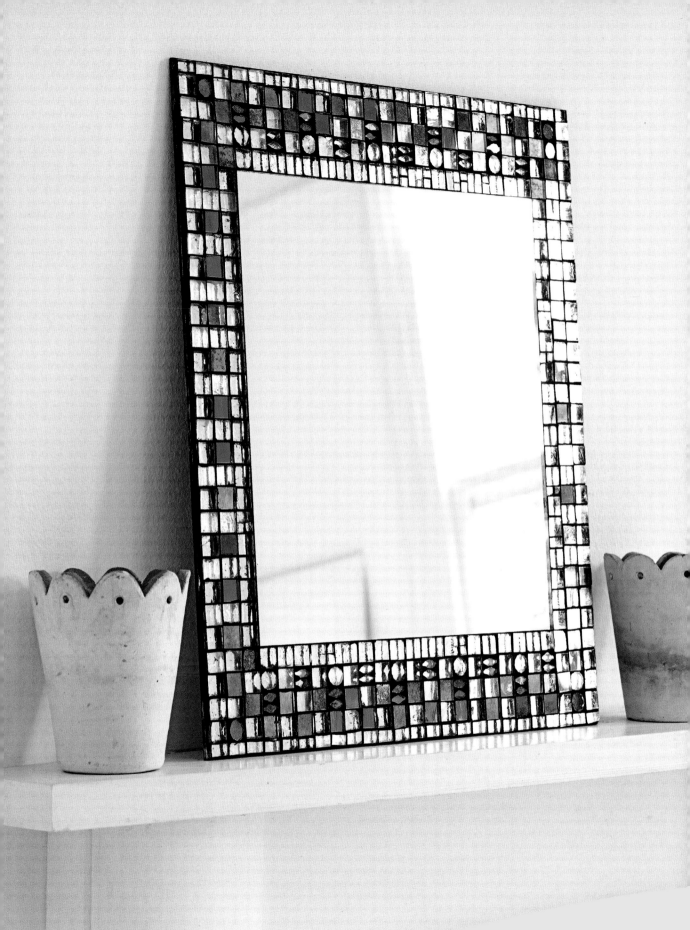

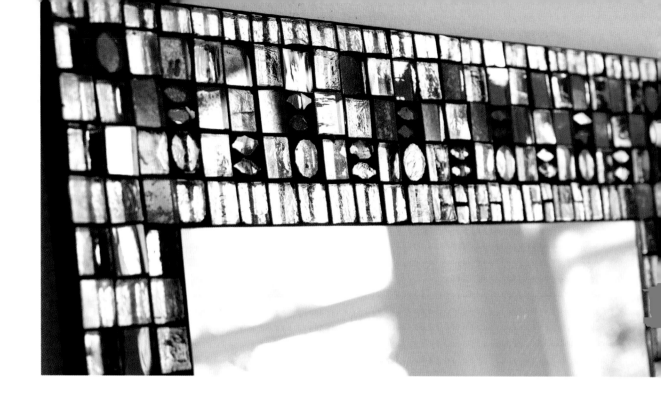

1 Ensure the dimensions of your mirror will allow you to use either whole or half Sicis glass tiles to make the frame. (Sicis glass tiles are 15 mm/⅝ in square.) Place the smaller piece of mirror exactly in the centre of the larger piece and secure using silicone glue (see page 25). Set aside until the glue is set.

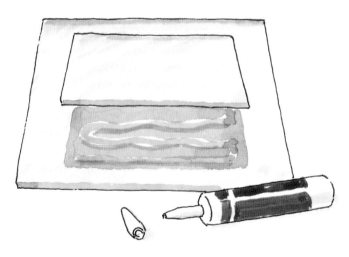

2 Referring to the photograph, draw the pattern for the frame on the larger piece of mirror using a non-permanent pen. The frame illustrated here comprises three rows of tiles by four and a half rows.

3 Cut four circles (see page 15) from the supply of antique and plain gold mirror squares you have already cut. Then cut a number of the squares into two equal halves and trim at the ends to make petal shapes. Similarly, trim a number of the plain and iridised Sicis glass tiles into circles, halves and petal shapes, as required.

4 Position the mirror landscape, with a longest side nearest you, and work from the inner edge of the frame outwards. Lay the pieces according to the following instructions although any design can be used as long as the pattern fits in.

5 Row 1: Lay a row of plain clear Sicis Waterglass all around the central mirror, with an antique mirror tile in each corner. Cut the odd tile in half or into three pieces to add interest. Secure the tiles carefully with silicone glue.

6 Row 2, top and bottom: Place another antique mirror tile in every corner then work along the second row, top and bottom, alternately laying an antique or plain gold mirror tile with a plain or iridised Sicis tile.

7 Row 2, left and right sides: Start at the mirror tile in the corner and work along the row away from you, completing both sides of the frame in the same way. Lay a plain or iridised Sicis tile, then stick two Sicis petal shapes in place of one tile, followed by another whole Sicis tile and then a circle cut from a Sicis tile. These four make the repeat pattern. Continue this pattern to the end of the row, finishing with a whole Sicis tile.

8 Row 3, top and bottom: Lay a row of whole Sicis tiles all the way along the edge of the mirror.

9 Row 3, left and right sides: Lay a Sicis circle, then lay a repeat pattern along the row comprising one gold tile, one whole Sicis tile, one gold tile, two gold petals. End with a whole Sicis tile.

10 Row 4, left and right sides only: Lay a whole Sicis tile, followed by a gold circle, then repeat the pattern of alternating a whole Sicis tile with a gold tile along the whole row.

11 Row 5, left and right sides only: Lay half Sicis tiles to complete the frame, making sure the cut edges are not exposed.

12 When the silicone is set, spend some time picking out any excess glue using a bradawl, then grout (see page 26) with black grout.

13 To mount the mirror, either stick it directly to the wall using super-strength glue (check manufacturer's instructions) or stick it to a sheet of MDF of the same size. Paint the sides of the MDF. Attach D-rings and picture wire to the reverse, and hang as a normal picture.

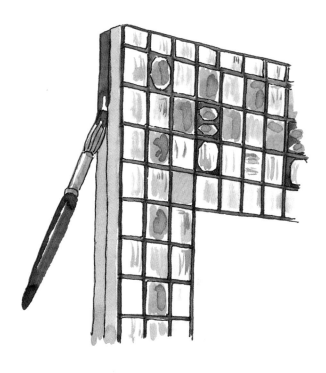

tools and materials
Slate roof tile, 250 x 480 mm (10 x 19 in)
Masking tape, drill and drill bit
Templates on page 125
Chalk
Exterior-grade tile adhesive
Disposable piping bag
Lead pencil
Black grout

mosaic pieces
Vitreous glass tiles: 60 x blue, for snail body and numbers;
 20 x shades of brown, for snail shell; 4 gold tiles, for
 border corners
Old china: selection of pieces in complementary colours and
 patterns, broken into circles and wedges, for snail shell
Millefiori: 20 blue
Shiny, textured or mirror tiles: 10 x blue
Unglazed ceramic tiles: 40 x white, for numbers background

Stick pieces of old colourful china and bright blue tiles on slate for a unique house number for your home. Discarded roofing slate is an attractive material in its own right, making it an ideal base for mosaics as there's no need to cover the whole surface. Just ensure the face of the slate is stable as pieces can sometimes break away. China is not generally frost proof, so the glaze may crack in extremely cold temperatures.

snail house number

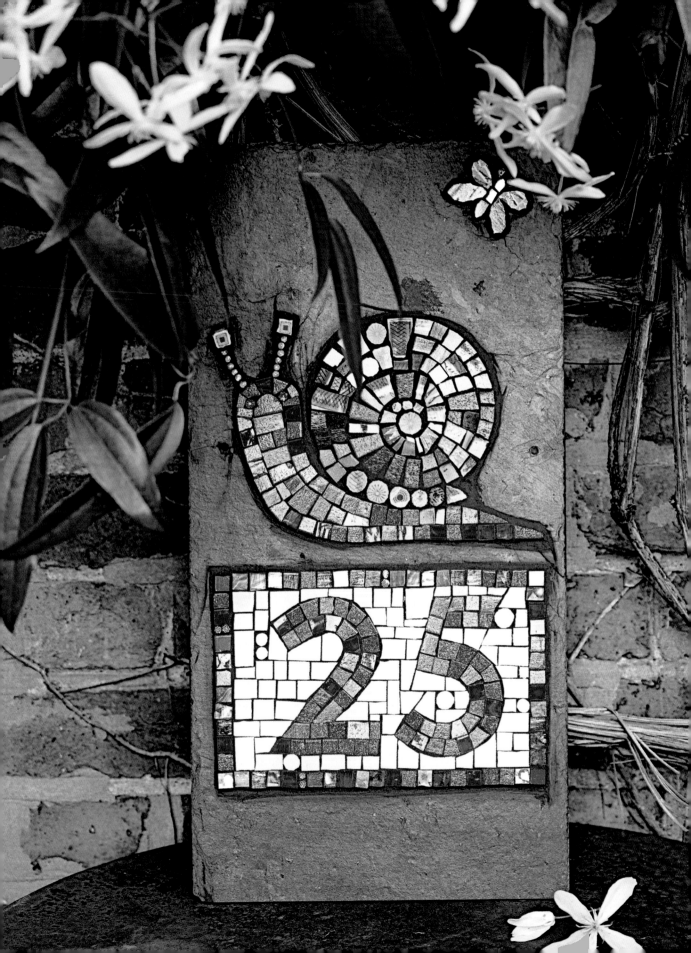

1 If there are not already holes in the slate in a useful position for installation, drill your own before you begin the mosaic and fill in the original ones later with grout. Stick a piece of masking tape down and drill through it to stop the drill bit sliding around on the slate.

2 Using the templates as a guide, chalk the house number(s), border and the snail and fly on the slate, ensuring the borders are straight and the numbers centred within them.

3 Start by laying the pieces for the snail's body, achieving a smooth outer line by cutting some of the blue vitreous glass tiles into wedge shapes as described on page 16. Stick the pieces in place using exterior-grade tile adhesive dispensed from a disposable piping bag.

4 When you have completed the snail outline, fill in the centre of the body with more pieces of blue vitreous glass tiles (see page 18 for different options for filling the snail), then use china for the tips of the 'horns' and millefiori for the 'horns' and eyes.

5 Use a mixture of brown vitreous glass tiles and broken china for the snail shell. Start the shell right in the centre with a circle of china (see page 15). Make sure you can achieve several circular runs to complete the shell by laying tiles as illustrated in a trial design before sticking them down. The shell starts with tiny pieces, graduates to tesserae about two-thirds the width of a whole tile, becomes two then three quarter-tiles deep, before tucking back under the shell in a single row.

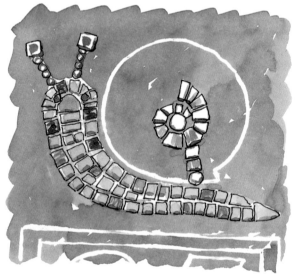

6 Mosaic a little fly into one corner of the slate, using a variety of tesserae.

7 House numbers need to be very clear so limit the textures within the numbers, working as neatly as possible to create really smooth, readable outlines in blue vitreous glass. Again, as with the snail, cut wedge shapes for the curves.

8 Next work on the border. Place a gold tile in each corner. Follow the marked guides carefully and add interest with some shiny, textured or mirror tiles in shades of blue. Leave the border to set, before mosaicing the background.

9 Breaking the white unglazed ceramic tiles for the background into pieces as you work, start by laying them at a curve, for example at the bottom front edge of the number two, or the inside curve of the number 5. Place your tile over the curve, mark the required cutting line with a lead pencil and nibble into shape.

10 It is worth plotting ahead to make sure you don't leave tiny spaces for the background tiles at the top or bottom edge of the panel. It is unlikely that your design will work out exactly so do use irregular spacing throughout the background, but keep the horizontal lines level. Introduce the odd circle into the background to reflect their use in the snail shell.

11 Grout (see page 26) the mosaics liberally using black grout, making sure there is a generous 45 degree slope of grout around all the edges. Lastly, smear the slate all over with grout so it has an even staining from the black grout. Now hang the mosaic and admire your handiwork.

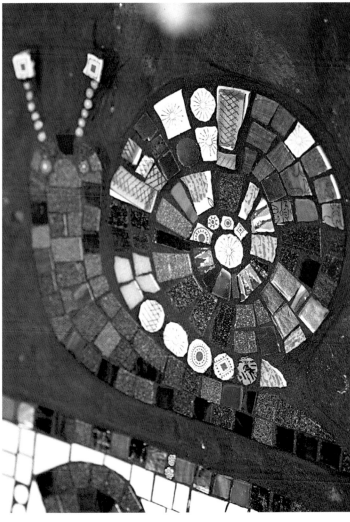

classic clock

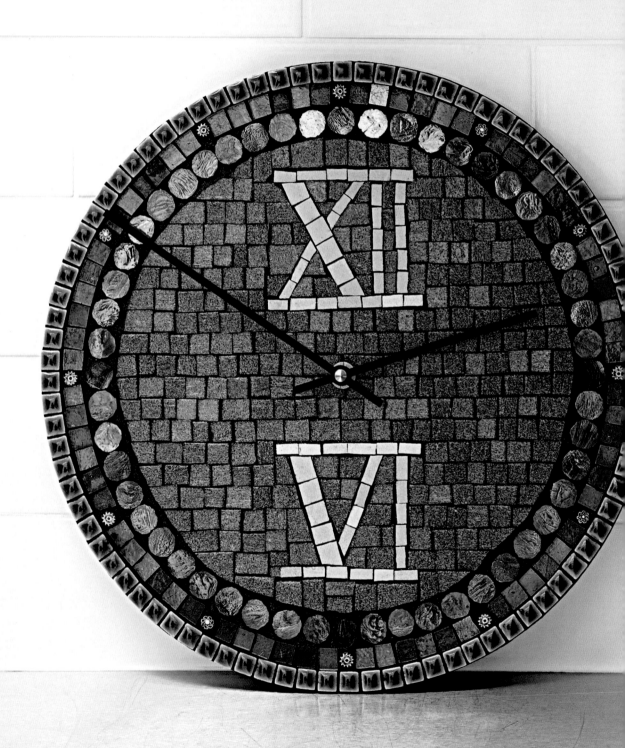

tools and materials

Clock face, 300 mm (12 in) diameter
Pencil or black marker pen and ruler
PVA glue
Craft tweezers
Pair of compasses
Template on page 125
Black grout
Clock movement

mosaic pieces

Mini porcelain glazed tiles, 10 mm (³/₈ in) square: 90 grey
Millefiori: 12 large
Gold leaf smalti: 85 in different shades
Sicis Iridium tiles: 60 brown and green, cut into circles
Unglazed ceramic tiles: 25 cream, cut into quarters
 and eighths
Vitreous glass tiles: 120 grey, most cut into quarters

This elegant design using classic roman numerals could be adapted to match your own décor. These greys would look smart in a home office, but the pretty greens make it equally suitable for display in a garden room or conservatory.

1 The ideal base for making up a clock face is an old clock face. This one is made of thick steel and since all the hours were already marked, there was no need for a template. Alternatively, buy an MDF clock base from a craft store or draw around a plate and cut out a disc of MDF using a jigsaw. Remember to drill a small hole in the middle for the working parts of the timepiece, which will be attached to the back of the clock.

2 Mark the positions of the hours on your clock face and join the 3 and the 9 positions together with a line.

3 Start by using the grey mini porcelain tiles. Quite chunky and entirely smooth, these tiles are great for the clock rim. Stick them around the outside of the clock using PVA.

4 Using tweezers, stick a large millefiori at the exact position of each hour. Form the second row around the clock by filling the space between each millefiori with whole gold leaf smalti, placed green glass up. (Gold leaf smalti is backed with different colours, creating different shades of green on the reverse, so choose several to provide variation.)

5 For the final circular row, stick a row of brown and green Sicis glass circles around the clock.

6 Using compasses and a black marker pen draw a circular line just inside the row of Sicis circles. This will form the border of the central background.

7 Using the template as a guide, mark the roman numerals XII and VI on the clock face. Using cream unglazed ceramic tiles, lay quarter-tiles for the broad strokes and half of those quarters for the finer strokes.

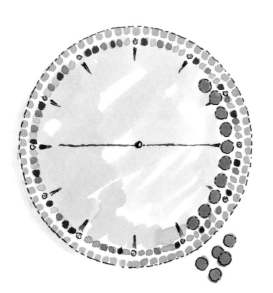

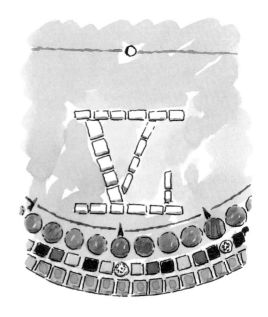

8 To complete the clock, fill the background with grey vitreous glass tiles. Work across the clock face, laying the first line sitting on the guideline running from the 3 to the 9, and remembering to leave a space for the clock movement. Work upwards in rows from this central line. Cut the tiles at each end of every background row at an angle to follow the marked line of the curve. Place these first, then fill the rest of the row with quarter-tiles.

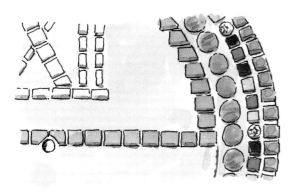

9 When you reach the numerals 'crash through' them with the background tiles, laying the tiles as though there was no obstacle. Shape tiles where they need to butt up to the numerals. When the top half of the clock is complete, work downwards in rows from the central line in exactly the same way.

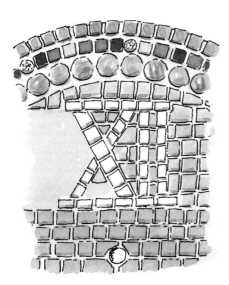

10 When the PVA has set, grout (see page 26) the clock face using black grout and attach the clock movement.

tools and materials

4 mm (5/32 in) glass panel, 600 x 250 mm (24 x 10 in) or cut to
 the width of your basin, with ground edges for safe handling
Silicone glue
Template on page 126
Non-permanent pen
Oil-filled glass cutter and running pliers
Weldbond (a type of PVA) (optional)
Bradawl or similar tool
Black grout
Super-strength sticky tabs

mosaic pieces

Smalti: 70–80 mixed and transparent blue, for top edge
Millefiori: 8–10 very large blue; 15–20 white, for fish bodies;
 10 blue, for fish tails; 2 circles, for eyes
Stained glass: 2 contrasting pieces (for example Uroboros and
 Youghiogheny ranges)
Vitreous glass tiles: 20 white, for faces and fins; 10 orange, for
 tails; 20 tan for the fish bodies; 60 plain dark blue and 60
 gold-veined blue, most cut into quarters, for background

This great-looking splashback panel is quick to make since large areas of the design disappear under pieces of stained glass much more rapidly than if using tiny mosaic pieces all over. When it comes to choosing stained glass there is a beguiling array of tantalizing colours, textures and finishes available.

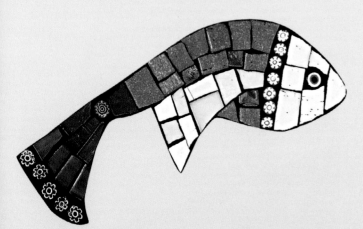

fishy splashback

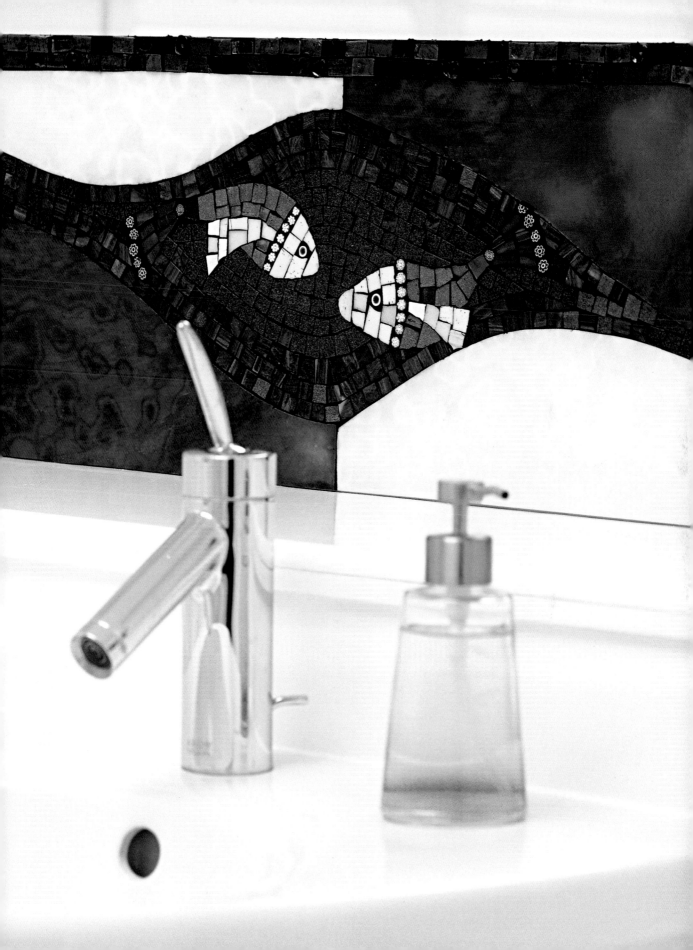

1 Using silicone glue, stick the assorted blue smalti bricks in two rows along the top edge of the glass panel. Intersperse with some large millefiori. Choose smalti pieces of a similar height to the one laid next to it and stagger the second row with a half-brick.

2 Using the template as a guide draw the desired curves on the pieces of stained glass in non-permanent pen. Score all four pieces using an oil-filled glass cutter (see page 12), then break the glass with running pliers. Following the template exactly isn't as important as making sure the adjacent pieces of stained glass meet to form a continuous smooth curve. (Note: if the front surface of the stained glass is textured you may need to score on the reverse. If so, bear in mind that the template must be reversed.)

3 Trim the four curved pieces of stained glass to the right length and stick them in position on the glass panel using silicone glue. Use plenty of adhesive, make sure all the air is squeezed out and the edges are sealed.

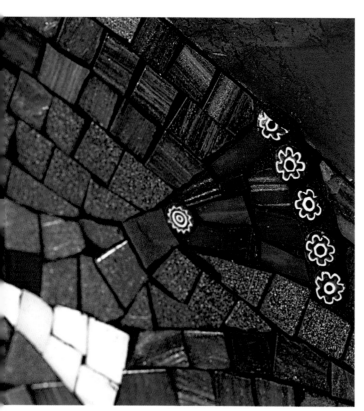

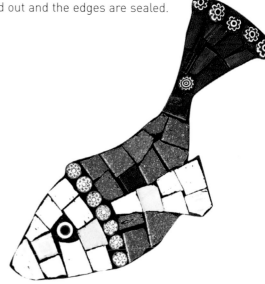

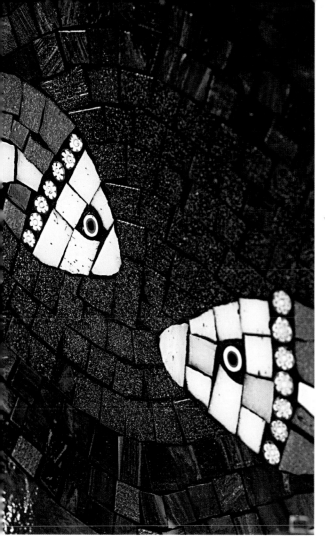

5 Lay the pieces for the fish as shown in the photograph on page 111, using vitreous glass and millefiori. Start with their faces and work towards their tails, cutting tiles into the required pieces as you work. Use Weldbond, or continue working with the silicone glue, as you prefer.

6 To fill in the background, work in rows from the outside edges next to the stained glass, moving in towards the middle. Lay gold-veined blue vitreous glass for the outer three rows and plain dark blue tiles for the central part, 'crashing through' the fish, judging how the tiles might fall if the fish weren't there.

4 Now there is a delightfully small area left to be mosaiced! Size up a drawing of the two fish and place on the work surface behind the glass, positioning them as desired.

7 Leave to dry for 24 hours. Using a bradawl, spend some time removing any excess silicone glue from around the smalti before grouting (see page 26) with black grout. It's a good idea to mask off the stained glass when grouting, as grout can get trapped in the small imperfections on the surface of the glass.

8 Fix the finished splashback panel to the wall with super-strength sticky tabs. These provide invisible fixings but the panel is not permanently fixed so you can take it with you if you move home.

tools and materials

Piece of slate, 420 x 250 mm (16^1/$_2$ x 10 in)

Masking tape, drill and drill bit

Pencil

Template on page 125

Brown craft paper, larger than the slate by 30 mm
 (1^1/$_4$ in) all round

Board, slightly larger than the brown craft paper

Strips of gummed paper

Diluted PVA and paintbrush

Craft tweezers

White tile adhesive

Disposable piping bag

Black grout

Damp sponge

Ruler or large spatula

Craft knife

mosaic pieces

Smalti: 100 white, for birds; 4 black, for birds' legs;
 60 mixed brown, for picture border; 2 navy, for
 birds' plumes

Millefiori: 2, for birds' eyes; 20 daisies and stars,
 for birds' plumes and background; 400 in two
 shades of gold (200 of each design), for
 background

Letterini, for names

Gold leaf smalti, 10 mm (3/8 in) square: 100 for the
 lower background

lovebirds wedding
plaque

A unique creation to mark a union – these two lovebirds with the names of the bride and groom in tiny mosaic letterini entwined in their plumes make an inimitable and thoughtful wedding gift.

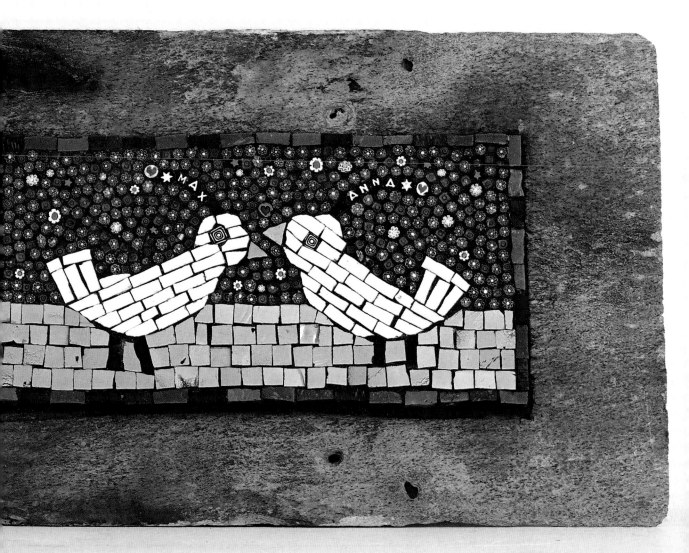

This mosaic uses smalti bricks laid on their flat sides so that they are all the same height. It is not easy cutting smalti bricks on their sides – to do so you need to pull out the pin that prevents wheeled nippers from opening wide. The cutting might end up slightly haphazard, but this creates a naïve look that suits the folksy feel of the mosaic.

The usual procedure for making an indirect mosaic is to make the mosaic upside down on brown craft paper and then flip it over (see page 20). In this instance, the mosaic is too heavy for this because of the amount of adhesive used, so it is turned over sandwiched between the slate base and a board. Planning for this part of the project in advance is essential. Read right to the end of the instructions to understand this before you start.

1 Drill holes in the piece of slate so it can be fixed to a wall (see Snail House Number, Step 1, page 104). Using a pencil, outline the exact size and position of the wedding mosaic on the piece of slate. Draw around the slate on to the piece of brown paper. Mark the exact position of the wedding mosaic within that outline, to match the position on the slate. Set the slate aside until later.

2 Stretch and secure the brown craft paper on a board with gummed paper (see page 20). Transfer the template's reversed design to the brown paper.

3 First make each bird right side up on your work surface, using the white smalti bricks on their sides. Then transfer the tiles to the paper and stick them 'good' face downwards using diluted PVA. It's a little hard to line them up but don't worry if it's not perfect – it adds to the character. Use a millefiori for each bird's eye. Next lay the black smalti for the birds' legs and the mixed brown smalti for the picture border, again laying them all on their sides. Leave these pieces to set.

4 Using tweezers, add the navy smalti plumes and the letterini to the birds, remembering that you are working in reverse and that the letters need to read correctly on the finished work. Lay four rows of gold leaf smalti, working up from the bottom of the picture and ensuring the gold side is to the paper, green side facing up. Cut the tiles that butt up to the birds as necessary (see page 18).

5 Fill in the remaining background using the gold millefiori and a few daisies and stars, leaving the background less 'busy' around the plumes so that the letters are clearly legible. Leave for 24 hours until the PVA is completely dry.

6 Do the next steps – pregrouting and sticking the mosaic on the slate – in swift succession. First mix the adhesive to a stiff consistency – white adhesive will make the millefiori appear brighter – and place in a disposable piping bag (see page 24). Set aside.

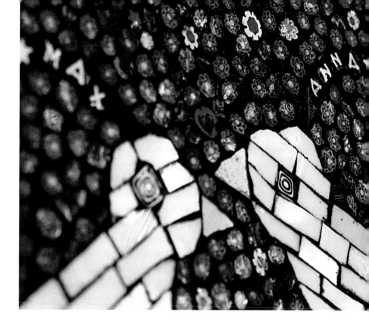

7 Pregrout the mosaic (see page 21) using black grout. It is a little hard to grout the sides of the mosaic, but you can do a more thorough job later, with the final grout. Clean up the back of the tesserae using a well-wrung sponge. Work swiftly before the paper starts to disintegrate (see page 21).

8 Now fill the 'tray' created by the high sides of the smalti bricks with the adhesive in the prepared piping bag. Squeeze the adhesive over the back of the millefiori and gold smalti until level with the border – very gently use a ruler or large spatula to level it off.

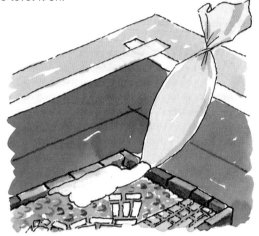

9 Lastly, spread some adhesive on the tops of the border tiles and the back of the birds. Work quickly and do not overfill or the border of smalti bricks will be forced outwards.

10 Run a craft knife through the brown craft paper, about 10 mm (3/8 in) away from the edge of the mosaic, releasing it from the board, but leave the mosaic in *exactly* the same position. Lay the slate over the work, aligning the edge of the slate with the guides drawn on the brown craft paper in Step 1. Press the slate down gently.

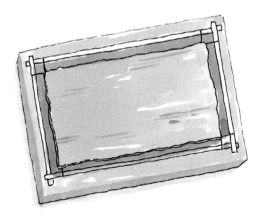

11 Holding both the board and the slate, flip the work over so that the slate is underneath and the board uppermost. Since the paper is not now fixed to the board you can simply lift the board away. You might need to adjust the smalti if the adhesive has forced them out. Leave for 15 minutes as the adhesive sticks to the slate, but keep the brown craft paper damp with a damp sponge.

12 Now gently ease back the craft paper (see page 21), already softened by the pregrouting and damp sponge.

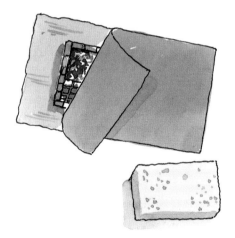

13 Clean up any grout that has spread on to the face of tiles and any visible excess white adhesive, remembering the adhesive is still soft so handle gently. Leave to dry. After 24 hours regrout in the normal way (see page 26) with black grout.

templates

The projects in this book can be adapted to suit your own preferences, but here are some useful templates if you would like to replicate the designs exactly.

For downloadable versions of the following templates please go to www.octopusbooks.co.uk/templates.

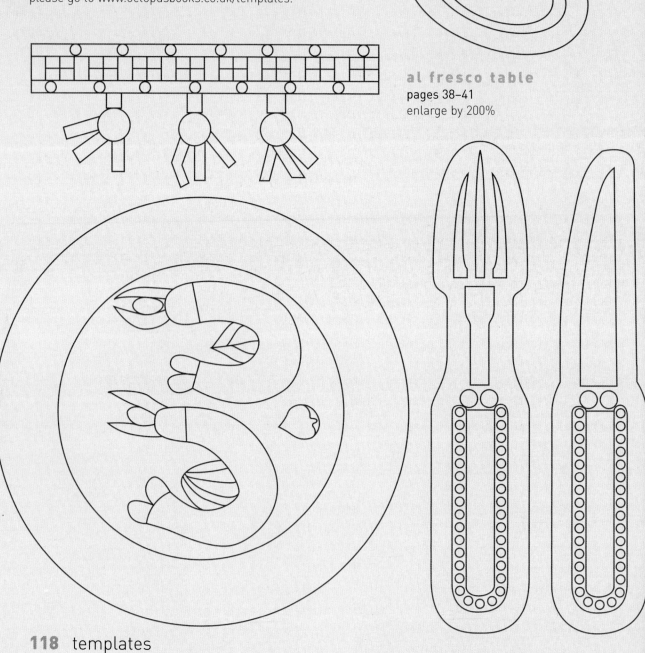

al fresco table
pages 38–41
enlarge by 200%

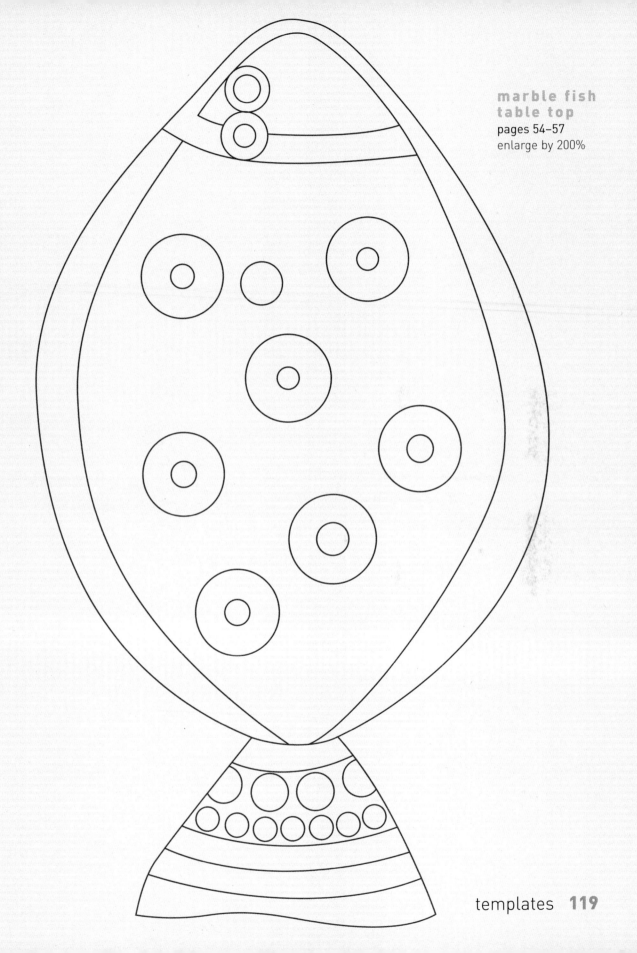

marble fish
table top
pages 54–57
enlarge by 200%

garden bubble
fountain
pages 60–63
enlarge by 200%, then enlarge
again by 150%

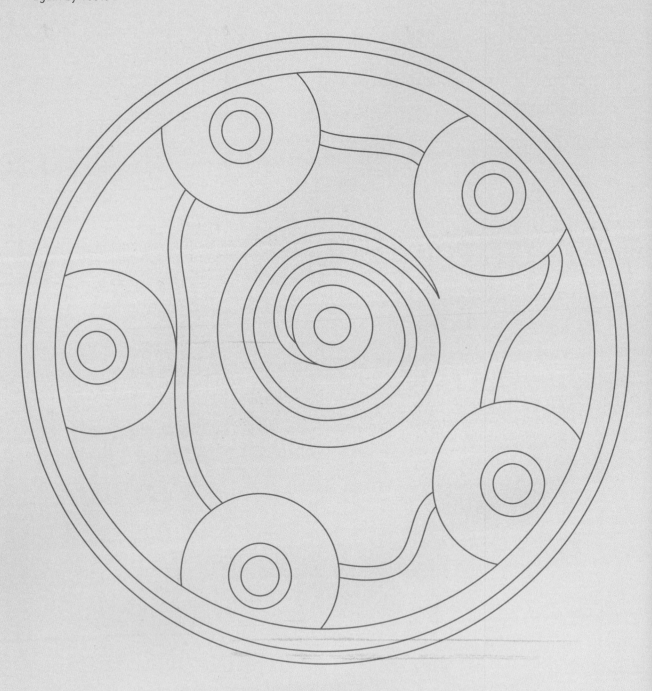

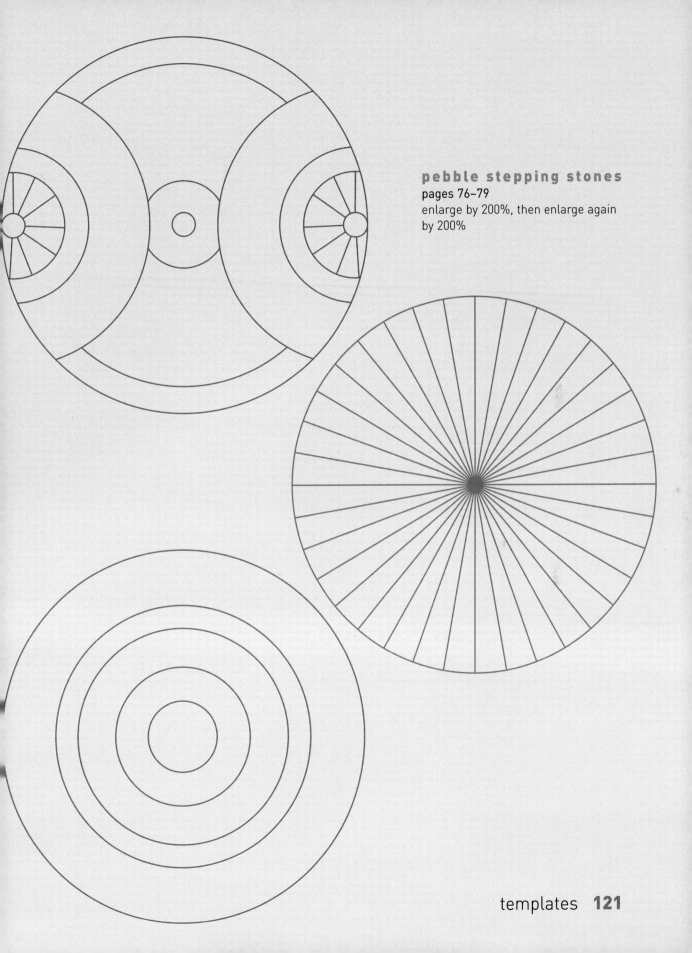

pebble stepping stones
pages 76–79
enlarge by 200%, then enlarge again
by 200%

zingy laundry box
pages 80–83
side design
enlarge by 200%

chillies tray
pages 42–45
enlarge by 200%

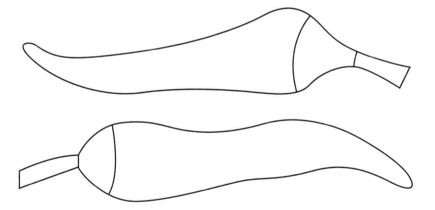

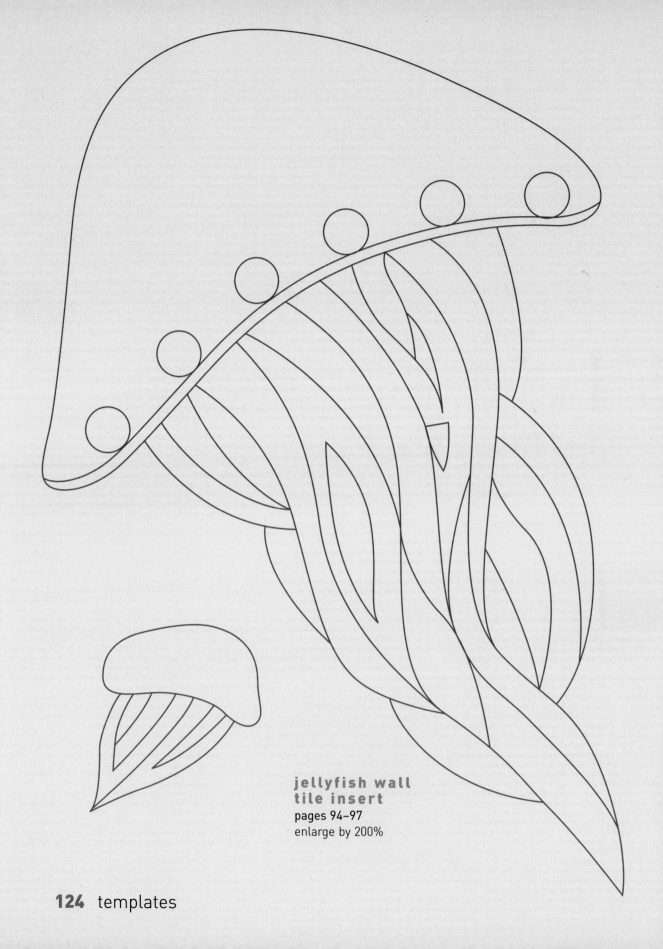

jellyfish wall
tile insert
pages 94–97
enlarge by 200%

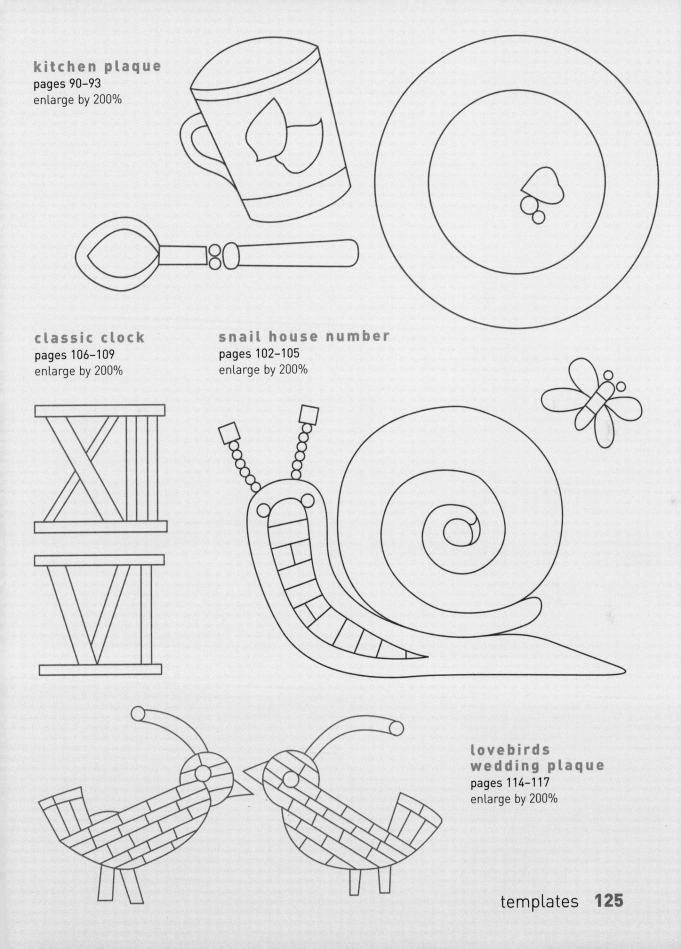

kitchen plaque
pages 90–93
enlarge by 200%

classic clock
pages 106–109
enlarge by 200%

snail house number
pages 102–105
enlarge by 200%

**lovebirds
wedding plaque**
pages 114–117
enlarge by 200%

fishy splashback
pages 110–113
enlarge by 200%, then
enlarge again by 200%

index

acknowledgements

Hamlyn would like to thank Mosaic Trader UK for the loan of tools and mosaic supplies for photography:

Mosaic Trader UK
26 Beaconsfield Road
Canterbury
CT2 7HF
www.mosaictraderuk.co.uk
+44 (0)1227 781 601

For information about Anne Cardwell's commissions and courses visit:
www.makingmosaics.co.uk

Other useful sources:
birdballs www.greenandblue.co.uk
glass baubles www.manufactum.com
millefiori www.muranomillefiori.com
millefiori and mexican smalti
 Michele@MuranoMillefiori.com
wooden cube tealight holders and polystyrene balls
 www.craftycomputerpaper.co.uk
stained glass www.tempsfordstainedglass.co.uk
general mosaic supplies www.xinamarie.com and
 www.reedharris.co.uk
pebbles www.maggyhowarth.co.uk
adhesives www.maipei.com and
 www.bal-adhesives.co.uk

Photography © Octopus Publishing Group Limited/Sandra Lane

Executive Editor Katy Denny/Jo Lethaby
Senior Editor Charlotte Macey
Executive Art Editor Sally Bond
Designer Janis Utton
Illustrators Kate Simunek/Sudden Impact Media
Production Controller Carolin Stransky